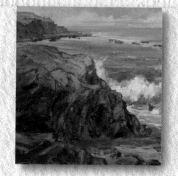

Landscapes

Oil is a captivating medium that has been popular with artists for centuries. Oil paint is well suited to many different artistic styles, from extremely detailed, photorealistic work to loose, colorful impressionistic paintings—and there is no better way to capture the majestic grandeur and vibrant colors of a beautiful landscape. This book is a unique compilation of step-by-step lessons from four renowned landscape artists. Individually they'll introduce you to their own perspectives on tools, techniques, special effects, and approaches to painting oil landscapes. From traditional pastoral scenes to lively cityscapes, you'll discover how exciting painting landscapes can be. And along the way, you'll find all the information and inspiration you'll need to choose your own subjects, develop your own style, and paint your own masterpieces in oil!

CONTENTS

Gathering Your Supplies	2
Applying Color Theory	4
Exploring Basic Techniques	6
Deciding What to Paint	8
Understanding Value	10
Portraying Street Scenes	12
Composing a Landscape	14
Creating Drama with Light and Shadow	16
Focusing on Architecture	18
Capturing Time of Day	20
Introducing Perspective	24
Depicting Depth	26
Painting Seascapes	30
Walter Foster Art Instruction Program	32

Gathering Your Supplies

THERE ARE SO MANY ITEMS to choose from in art supply stores, it's easy to get carried away and want to bring home one of everything! However you only need a few materials to get started. A good rule of thumb is to always buy the best products you can afford. And think of your purchase as an investment—if you take good care of your brushes, paints, and palette, they can last a long time, and your paintings will last for generations. The basic items you'll need are described here, but for more information, you can refer to *Oil Painting Materials and Their Uses* by William F. Powell in Walter Foster's Artist's Library series.

Buying Oil Paints

There are several different grades of paint available, including students' grade and artists' grade. Even though artists' grade paints are a little more expensive, they contain better-quality pigment and fewer additives. The colors are more intense and will stay true longer.

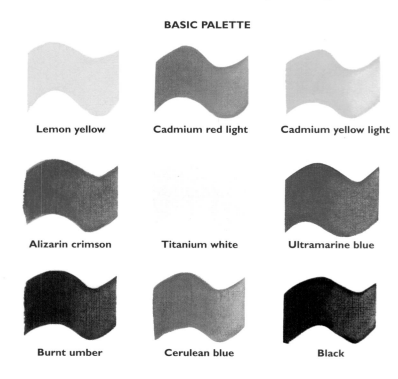

BASIC PALETTE

Lemon yellow · Cadmium red light · Cadmium yellow light

Alizarin crimson · Titanium white · Ultramarine blue

Burnt umber · Cerulean blue · Black

Choosing a Palette of Colors

The nine colors shown above are a good basic palette (including a warm and cool version of each of the primary colors). Each artist featured in this book has some unique colors in his or her palette, so these lessons will give you an opportunity to try out some other colors. Keep in mind that there is always more than one way to mix a color—once you understand the basics of color theory, you can get a better feel for the art of mixing color. The more you practice and experiment, the easier it will seem! (For more on color, please see pages 4–5.)

Adding to the Palette

For the lessons in this book, you'll need to add one or more of the colors listed below to your basic palette. (Refer to each project for a complete listing of colors needed.)

- ❑ cadmium yellow deep
- ❑ sap green
- ❑ cadmium orange
- ❑ yellow ochre
- ❑ cobalt blue
- ❑ medium blue
- ❑ cadmium yellow pale
- ❑ quinacridone rose
- ❑ quinacridone red
- ❑ quinacridone violet
- ❑ transparent oxide red
- ❑ raw sienna
- ❑ phthalocyanine (phthalo) blue
- ❑ terra rosa
- ❑ Carbazole violet
- ❑ viridian green
- ❑ phthalo green
- ❑ phthalo yellow-green

Selecting Supports

The surface on which you paint is called the *support*—generally canvas or wood. You can stretch canvas yourself, but it's simpler to purchase prestretched, preprimed canvas (stapled to a frame) or canvas board (canvas glued to cardboard). If you choose to work with wood or any other porous material, you must apply a *primer* first to seal the surface so the oil paints will adhere to the support (instead of soaking through).

FINDING THE RIGHT SIZE Stretched canvases, canvas boards, and wood boards are available in standard sizes. If you want a custom size, you can stretch your own canvas or cut down a wood board.

Purchasing and Caring for Brushes

Oil painting brushes vary greatly in size, shape, and texture. There is no universal standard for brush sizes, so they vary slightly among manufacturers. Some brushes are sized by number, and others are sized by inches or fractions of inches. Just get the brushes that are appropriate for the size of your paintings and are comfortable for you to work with. The six brushes pictured below are a good starting set; you can always add to your collection later. Brushes are also categorized by the material of their bristles; keep in mind that natural-hair brushes are best for oil painting. Cleaning and caring for your brushes is essential—always rinse them out well with turpentine and store them bristle side up or flat (never bristle side down).

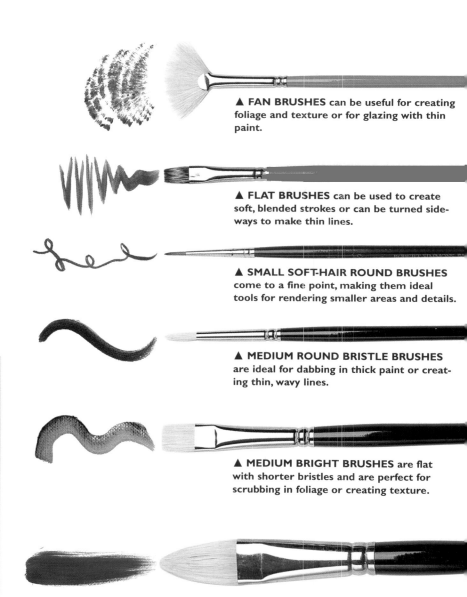

▲ **FAN BRUSHES** can be useful for creating foliage and texture or for glazing with thin paint.

▲ **FLAT BRUSHES** can be used to create soft, blended strokes or can be turned sideways to make thin lines.

▲ **SMALL SOFT-HAIR ROUND BRUSHES** come to a fine point, making them ideal tools for rendering smaller areas and details.

▲ **MEDIUM ROUND BRISTLE BRUSHES** are ideal for dabbing in thick paint or creating thin, wavy lines.

▲ **MEDIUM BRIGHT BRUSHES** are flat with shorter bristles and are perfect for scrubbing in foliage or creating texture.

▲ **BRISTLE-HAIR FILBERTS** can hold a considerable amount of paint and are generally used for blocking and painting in larger areas.

Utilizing Additives

Mediums and thinners are used to modify the consistency of your paint. Many different types of oil painting mediums are available—some thin out the paint (linseed oil) and others speed drying time (copal). Still others alter the finish or texture of the paint. Some artists mix a small quantity of turpentine with their medium to thin the paint. You'll want to purchase some type of oil medium, since you'll need something to moisten the paint when it gets dry and stiff and to thin it for glazing and underpaintings. Turpentine or mineral spirits can be used to clean your brushes and for initial washes or underpainting, but you won't want to use them as mediums. They break down the paint, whereas the oil mediums you add actually help preserve the paint.

SELECTING AN EASEL The easel you choose will depend on where you plan to paint; you can purchase a studio or tabletop easel for painting indoors, or a portable easel if you are going to paint outdoors.

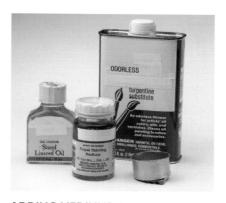

ADDING MEDIUMS In addition to the medium you choose, be sure to purchase a glass or metal cup to hold the medium. Some containers have a clip built into the bottom that attaches easily to your mixing palette.

FINISHING UP Varnishes are used to protect your painting—spray-on varnish temporarily sets the paint, and brush-on varnish will permanently protect your work. See the manufacturer's instructions for application guidelines.

CLEANING BRUSHES Purchasing a jar that contains a screen or coil can save some time and mess. As you rub the brush against the coil, it loosens the paint from the bristles and separates the sediment from the solvent. Once the paint has been removed, you can use brush soap and warm (never hot) water to remove any residual paint. Then reshape the bristles of the brush with your fingers and lay it out to dry.

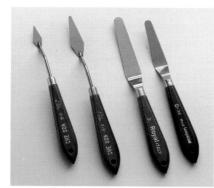

USING PAINTING AND PALETTE KNIVES Palette knives can be used either to mix paint on your palette or as a tool for applying paint to your support. Painting knives usually have a smaller, diamond-shaped head, while palette (mixing) knives usually have a longer, more rectangular blade. Some knives have raised handles, which help you avoid getting wet paint on your hand as you work.

Checklist of Basics

Below is a list of the materials you'll need to purchase to get started painting in oils. (For specifics, refer to the suggested brushes and colors on page 2.)

- ❏ 9 basic oil colors
- ❏ Medium (copal or linseed oil)
- ❏ Palette and palette paper
- ❏ Palette knife
- ❏ Supports
- ❏ 6 brushes
- ❏ Thinner (mineral spirits or turpentine)
- ❏ Containers for thinner and medium
- ❏ Easel
- ❏ Paper towels

Picking a Palette

Whatever type of mixing palette you choose—glass, wood, plastic, or paper—make sure it's easy to clean and large enough for mixing your colors. Glass is a great surface for mixing paints and is very durable. Palette paper is disposable, so cleanup is simple, and you can always purchase an airtight plastic box (or paint seal) to keep your leftover paint fresh between painting sessions.

Including the Extras

Paper towels or lint-free rags are invaluable when oil painting; you will use them to clean your tools and brushes, and they can also be used as painting tools to scrub in washes or soften edges. Some type of paint box is also useful to hold all your materials. In addition, you may want charcoal or a pencil for sketching and a mahlstick to help you steady your hand when working on a large support.

GATHERING EXTRAS In addition to the basic tools, you may also want to acquire a silk sea sponge and an old toothbrush to render special effects. Even though you may not use these additional items for every oil painting you work on, it's a good idea to keep them on hand in case you need them.

SETTING UP A WORK STATION How you set up your workspace will depend on whether you are right- or left-handed. It's a good idea to keep your supplies in the same place, so that each time you sit down to paint, you don't have to waste time searching for anything. If natural light is unavailable, make sure you have sufficient artificial lighting, and above all else, make sure you're comfortable!

Applying Color Theory

A COLOR WHEEL can be a handy visual reference for mixing colors. All the colors on the color wheel are derived from the three *primary colors* (yellow, red, and blue). The *secondary colors* (purple, green, and orange) are each a combination of two primaries, and *tertiary colors* are mixtures of a primary and a secondary (red-orange, yellow-orange, yellow-green, blue-green, blue-purple, and red-purple). *Complementary colors* are any two colors directly across from each other on the color wheel, and *analogous colors* are any three colors adjacent on the color wheel. When discussing color theory, there are several terms that are helpful to know. *Hue* refers to the color itself, such as red or yellow-green; *intensity* refers to the strength of a color, from its pure state (right out of the tube) to one that is grayed or diluted; and *value* refers to the relative lightness or darkness of a color or of black.

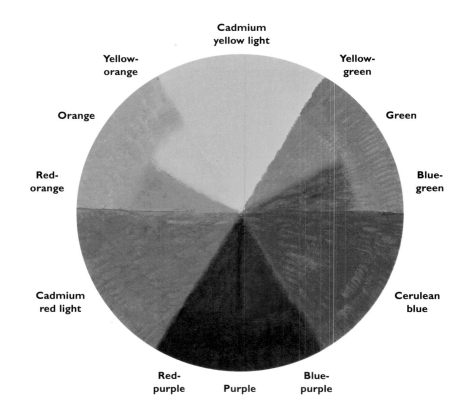

▲ COLOR WHEEL Knowing the fundamentals of how colors relate to and interact with one another will help you create feeling—as well as interest and unity—in your oil paintings. You can mix just about every color from the three primaries. But all primaries are not created alike, so you'll eventually want to have at least two versions of each primary, one warm (containing more red) and one cool (containing more blue). These two primary sets will give you a wide range of secondary mixes.

Value

The variations in value throughout a painting are the key to creating the illusion of depth and form. On the color wheel, yellow has the lightest value and purple has the darkest value. You can change the value of any color by adding white or black (see the chart at left). Adding white to a pure color results in a lighter value *tint* of that color, adding black results in a darker value *shade*, and adding gray results in a *tone*. (A painting done with tints, shades, and tones of only one color is called a *monochromatic* painting.) In a painting, the very lightest values are the *highlights* and the very darkest values are the *shadows*.

Complementary Colors

As stated above, complements are any two colors directly opposite each other on the color wheel, such as red and green, yellow and purple, or blue and orange. When placed next to each other, complementary colors create visual interest, but when mixed, they neutralize (or "gray") one another. For example, to neutralize a bright red, mix in a touch of its complement: green. By mixing varying amounts of each color, you can create a wide range of neutral grays and browns. (In painting, mixing neutrals is preferable to using them straight from a tube; neutral mixtures provide fresher, realistic colors that are more like those found in nature.)

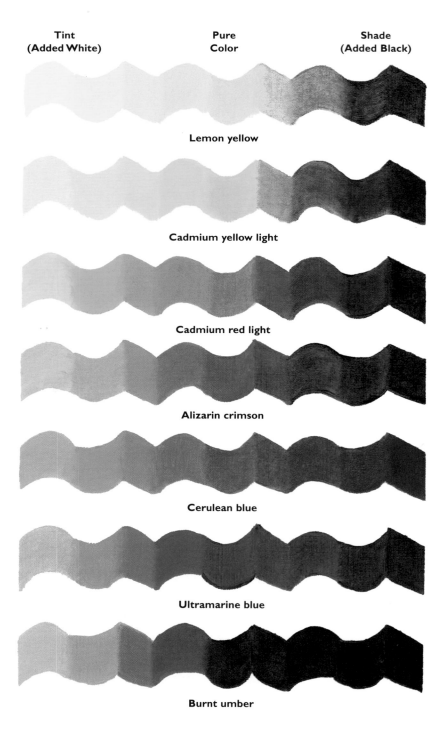

Tint (Added White)	Pure Color	Shade (Added Black)

Lemon yellow

Cadmium yellow light

Cadmium red light

Alizarin crimson

Cerulean blue

Ultramarine blue

Burnt umber

▲ TINTS AND SHADES The chart above shows varying tints and shades of different colors. The pure color is in the middle of each example; the tints are to the left, and the shades are to the right.

► DIRECT COMPLEMENTS Each of these examples is a pair of direct complements. Direct complements create the most striking contrasts when placed next to one another. When you want to create drama or vitality in your paintings, place a color next to its complement.

Understanding Color Psychology

Colors on the red side of the color wheel are considered to be "warm," while colors on the blue side of the wheel are thought of as "cool." Warm colors can convey energy and excitement, whereas cool colors can evoke a calm, peaceful mood. Within all families of colors, there are both warm and cool hues. For example, a cool red (such as alizarin crimson) contains more blue, and a warm red (such as cadmium red) contains more yellow. Keep in mind that cool colors tend to recede, while warmer colors appear to "pop" forward. This is especially relevant for painting landscapes, as you can use the contrast between warm and cool colors to help portray a sense of distance in a scene.

Mixing Color

Successfully mixing colors is a learned skill, and, like anything else, the more you practice, the better you will become. One of the most important things is to train your eye to really *see* the shapes of color in an object—the varying hues, values, tints, tones, and shades of the subject. Once you can see them, you can practice mixing them. If you're a beginner, you might want to go outside and practice mixing some of the colors you see in nature at different times of day. Notice how the colors of things seem to change as the light changes; the ability to discern the variations in color under different lighting conditions is one of the keys to successful color mixing.

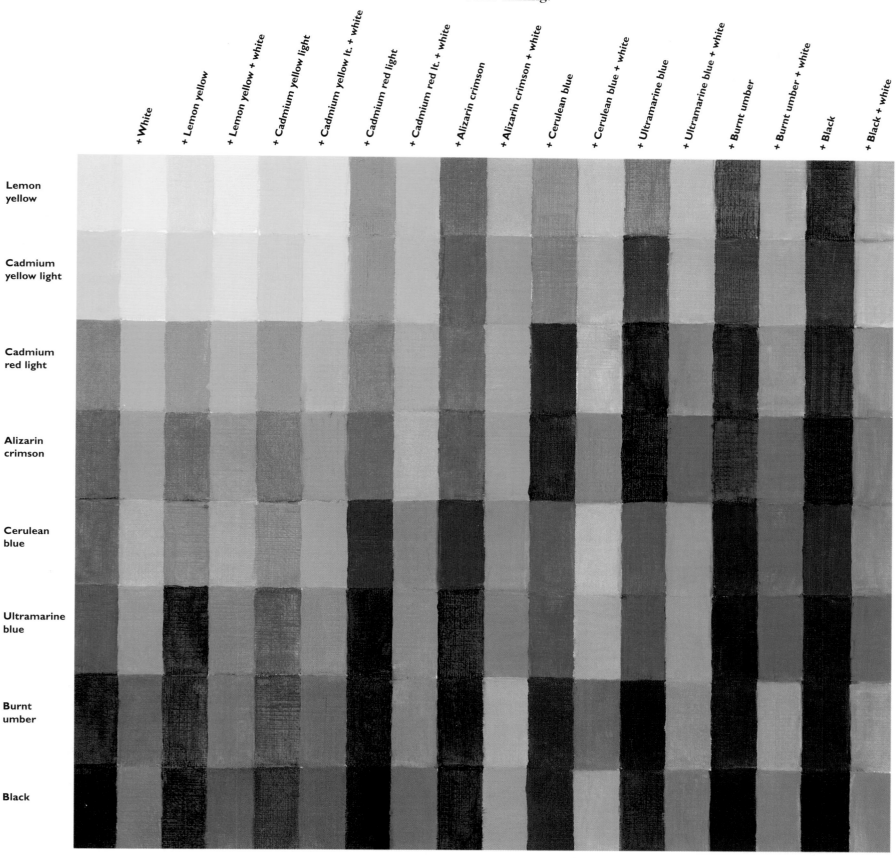

USING A LIMITED PALETTE You don't need to purchase dozens of tubes of paint to be able to mix a vast array of hues. Instead you can use a limited number of paints and mix the other colors you need. The chart above shows just some of the colors that can be made using the nine colors found in the basic palette listed on page 2. You may want to create your own chart using the colors from your palette; this is an excellent exercise in learning to mix color.

Exploring Basic Techniques

THERE ARE MANY DIFFERENT WAYS to approach a blank support. Some artists begin by *toning* the support, or covering it with a thin wash of color. This underpainting provides a base to build colors on, and it is sometimes even allowed to show through in places in the final painting. Using a toned support can help you avoid ending up with "holes" in the final piece that somehow didn't get painted. Generally a toned background is a fairly neutral color; warm colors work well for earth-toned subjects, and blue or another cool hue suits most other subjects. Another approach to oil painting is to build up gradual layers of paint by applying successive *glazes* (very thin mixtures of diluted pigment). The paint is thinned with medium and then applied with a soft brush over an area that's already dry. Other artists prefer to apply thick applications of paint directly to the support, sometimes blending and reworking the painting as they go. No matter how you begin, it's the final application of the color that will determine the feel of your painting.

Working with Painting Tools

The energy of your strokes will translate directly to your painting. The way you hold your tool, how much paint you load on it, the direction you turn it, and the way you manipulate it will all determine the effect of your stroke. For example, you may use thick paint and broad, angular slashes to render the sharp edges of a cliff, or you may create soft, light, dabbing strokes with thin paint to create foliage. The type of brush you use also has an effect; bristle brushes are stiff and generally hold a generous amount of paint. Bristle brushes are excellent for covering large areas or for scrubbing in underpaintings. Soft-hair brushes (such as sables) are well suited to soft blends and glazes, and they can also be used to create fine lines and intricate details. The more you work with your tools, the more familiar you will become with the effects you can achieve with them. The examples here illustrate some of the techniques you can use to render realistic textures and subjects with oil paint.

KNIFE WORK To create thick texture, load the edge of a painting knife with color and place the side of the blade on the support. Then draw it down, letting the paint "pull" off the knife and onto the canvas. You can also use this effect to blend colors directly on your support.

IMPASTO To punctuate highlights or add texture, apply very thick layers of paint to the support (called "impasto"). This texturizing technique creates thick ridges of paint; the dramatic brushstrokes are not blended together but remain visible.

SCUMBLE Scumbling is an excellent technique for rendering mist or haze to help convey distance in a landscape. With a dry brush, lightly apply semi-opaque color over dry paint, allowing the underlying colors to show through.

SMEAR For realistic rocks or mountains, use a palette knife to lightly smear layers of color over another color or directly onto the support. Your strokes should blend the colors slightly, but overworking the area will ruin the texture.

SCRATCH To effectively render rough textures such as bark, use a palette knife and quick, vertical strokes to scratch off color. Use the side of the knife, leaving grooves and indentations of various shapes and revealing the underlying color.

DAB To achieve a soft, gradual blend, try dabbing color onto the support. Using vertical tapping strokes with a brush or your finger, apply or gently blend the color. You don't need to apply very much pressure; the lighter your touch is, the softer the blend will be.

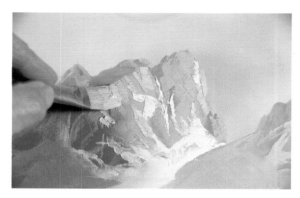

SLASH Rocks and mountains have jagged, jutting planes and edges. By making angular strokes that follow the direction of the different planes, you can create realistic rocky textures. Use a bristle brush or palette knife for best results.

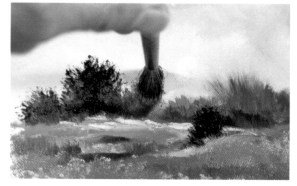

STAMP AND LIFT This is a quick and easy way to create background foliage. Using a round bristle brush loaded with paint, push the brush onto the canvas, and then pull it away to stamp a bush. Stroke up with the brush as you lift to create tall grasses.

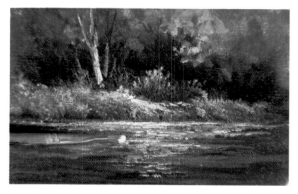

DRAG Dragging is perfect for rendering sunlight glistening on the water; pull the brush lightly across the canvas to leave patterns of broken color over another color. Use a "hit and miss" technique so that the highlights appear to "dance" across the water.

Blending Large Areas

A hake brush is handy for blending large areas, such as backgrounds and skies. While the area you want to blend is still wet, use a clean, dry hake to lightly stroke back and forth over the color for a smooth, even blend. These soft brushes often leave stray hairs on your canvas, so be sure to remove them before the paint dries. And never clean your hake in thinner until you're sure you're done blending for the rest of the painting session; these brushes take a long time to dry.

Experimenting with Special Techniques

Although a brush is a standard tool for artists, there are many other tools you can use to create special effects in oil painting. A palette knife, a rag, a sponge, and even your finger can be used to create texture and highlights in a painting. Special techniques in oil can help you accomplish a variety of exciting variations with your paints, including realistic textures for rocks and sand, complex patterns for starry skies or tangled foliage, and even natural-looking objects like clouds and trees. Experiment with them all to discover the many ways in which you can enhance your paintings.

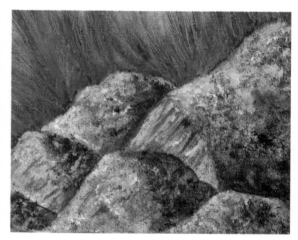

SPONGE A sponge is a simple texturizing tool. Here different colors are sponged on in layers, creating the appearance and texture of stone.

STIPPLE For reflections or highlights, use a stiff bristle brush and hold it very straight, bristle side down. Then dab on the color quickly, creating a series of small dots.

SCRAPE Use the tip of a palette knife to scrape color away. This can create an interesting texture or represent grasses.

SPATTER Spattered paint produces a pattern of tiny dots that can provide a realistic appearance for rocks or sand. To spatter, load a brush with paint and tap your finger against the handle to let the color loose. (You can also use an old toothbrush to create the same effect.)

WIPE AWAY To create subtle highlights, wipe paint off the support with a paper towel or blot it with tissue or newspaper. To wipe off paint to lighten the color or to "erase" mistakes, use a rag moistened with thinner or solvent.

SOFT BLEND For a soft blend, lay in the base colors and lightly stroke the brush back and forth to pull the colors together. Make sure that you don't overwork the area; overblending can muddy up the color and erase the contrasts in value.

Deciding What to Paint

by William Schneider

NATURE IS FULL of so many exciting possibilities for landscape painters—fascinating subjects are literally all around you! Your interest may be piqued by a colorful sunset, a peaceful pastoral scene, or a vast mountain range. Once it's time to translate the scene to the canvas, most artists don't paint from memory or imagination—they use reference materials for inspiration and information.

Using References

Some landscape artists go outdoors and paint on site, called painting "en plein air." Other artists paint in their studios using photos as reference materials, and others prefer to work from quick studies—or *field studies*—they have painted on location. A field study captures all the information you'll need to translate your reference to a full-sized canvas, including the crucial relationships between value, color, and design. Landscape artist William Schneider begins with a field study of this autumn scene because he feels on-site studies are the most accurate reference tools. A simple field study like this one may only take 30 minutes to create on site, but it will become an invaluable source for helping you to capture the true feeling of the scene you're painting.

▶ **SKETCHING ON LOCATION** I always carry a sketchbook with me and make simple drawings of anything that catches my eye. I also make color notes and indicate the the direction of the light source and the main highlights and shadows.

Color Palette

alizarin crimson, black, cadmium red light, cadmium yellow deep, cadmium yellow light, lemon yellow, raw sienna, terra rosa, titanium white, transparent oxide red, ultramarine blue, viridian green

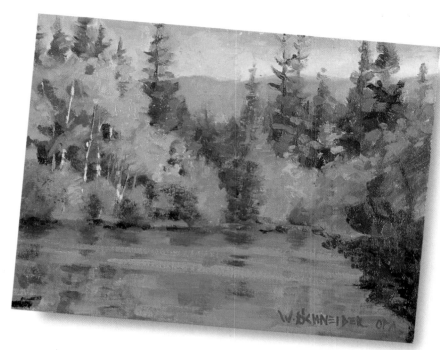

▲ **OBSERVING COLOR** This quick field study that I painted on site helps me gauge the actual colors I observed in this scene. When painting fall colors, the natural tendency is to make them too intense. Try this experiment when painting outdoors: Tie a yellow or red piece of cloth to a tree, and you'll see how much grayer the leaves really are in comparison.

SKY	SKY REFLECTIONS	LIGHT TREE MIX	DARK TREE MIX	LIGHT ASPENS	SHADOWED ASPENS
White, lemon yellow, ultramarine blue, and black	white and lemon yellow with more ultramarine blue and black	Ultramarine blue, lemon yellow, terra rosa, raw sienna, and white	Light tree mix plus more ultramarine blue	Cadmium yellow deep, cadmium yellow light, and white	Ultramarine blue, cadmium red light, white, and raw sienna

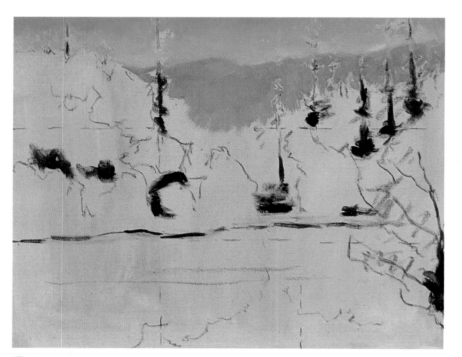

1 I was fascinated by the many colors my field study revealed in this scene and decided to render this landscape in more detail. I begin by toning my canvas with a thin wash of cadmium red light, terra rosa, and ultramarine blue. Using vine charcoal, I divide the canvas into thirds horizontally and vertically and sketch in the main landmarks, referring to my field study as I draw. I establish the darks with a mix of ultramarine blue, alizarin crimson, and transparent oxide red and then block in the background (see step 2).

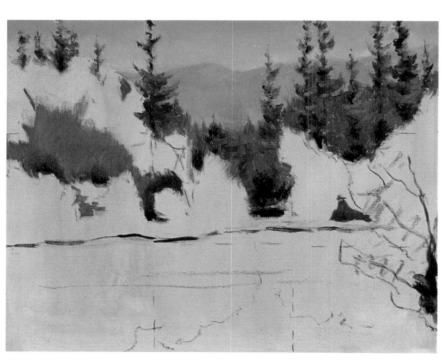

2 I establish some of the secondary darks with a mixture of ultramarine blue, transparent oxide red, alizarin crimson, and raw sienna. As I lay in a light blue for the sky (see sample above), I flatten and smooth out the edges with a palette knife. I darken the top of the sky by adding black and ultramarine blue to the mix and then paint in the mountains with a mixture of ultramarine blue, terra rosa, raw sienna, and white. For the distant gray trees, I use a mix of ultramarine blue, raw sienna, alizarin crimson, and a little white.

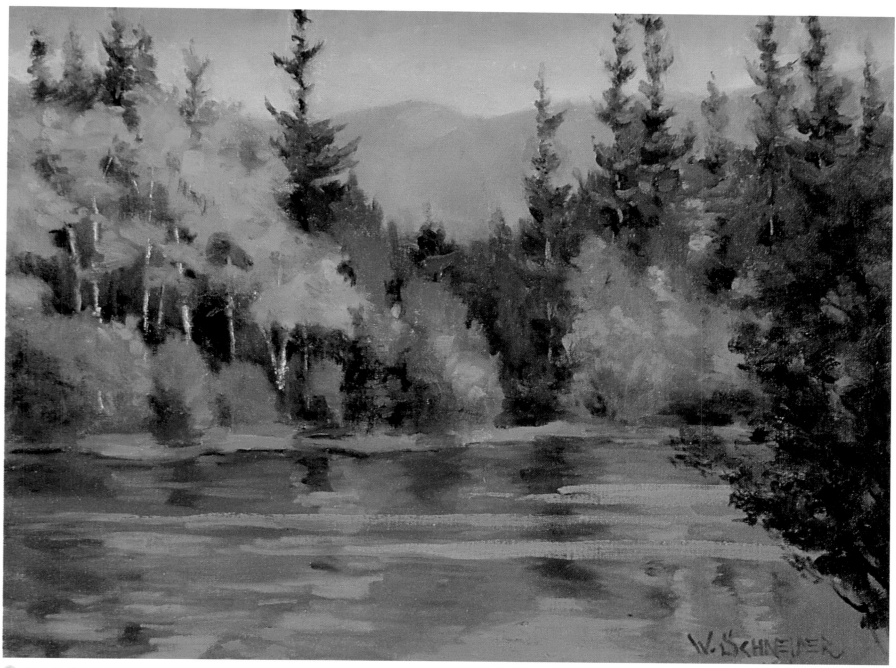

5 Now I paint the aspens using a mix of cadmium yellow deep and cadmium yellow light and some of the shadow colors (see page 8). I also paint the aspen trunks with a mix of white and raw sienna. Adding a little ultramarine blue and cadmium red light to the mixture, I work the reflections of the aspens into the water. Then I mix some of the dark sky color with a little black and add the reflections of the sky in the water.

Using a medium bristle brush and thick paint, I drag this color across the water in a single stroke to indicate ripples on the water. For the bush in front, I begin with the shadows and then add the thick highlights. Using a small sable and some of the bush reflection color, I paint "holes" in the bush where the distant trees show through. Finally I add a little detail to the bushes in the middle ground and sign my name.

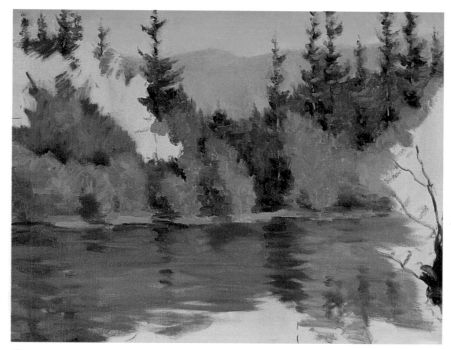

3 I block in the rest of the trees with both light and dark green tree mixes (see page 8). I paint the front pines with a mix of ultramarine blue, black, cadmium yellow light, and a speck of white. The tops of the branches reflect the sky, so I add viridian green, white, and alizarin crimson to the mix. Using two small sable brushes (one with sky color and one with tree color), I alternate between using both brushes, blending and softening the edges where the trees meet the sky. Then I block in the water.

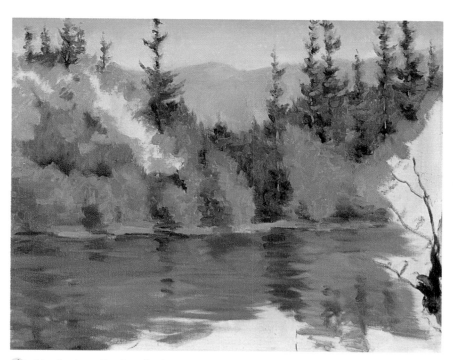

4 I lay in the reflections in the water using the tree mixtures that I've grayed down with more terra rosa, raw sienna, and white. Painting thinly, I lay them in with horizontal strokes and a large bristle brush to show movement in the water. For the dark reflections, I add ultramarine blue and terra rosa to the mix. I block in the shadows of the aspens with a grayed, purplish mix of ultramarine blue, cadmium red light, white, and raw sienna.

Understanding Value

by William Schneider

ONE OF THE MOST IMPORTANT lessons in painting is to learn to see the variations of values in your subject; accurately depicting the relationships among values will create the illusion of three-dimensional form in your landscape paintings. Sometimes the differences in values are obvious; strong contrasts between darks and lights make it easy to see where the values change. With other subjects, the differences in value are more subtle. For example, you have to look very closely at a bouquet of white roses to see all the slight color nuances among the petals. Painting a white subject offers the perfect opportunity to practice seeing values.

Working with White

In oil painting, white is not the absence of color; rather, a white object reflects all the colors that surround it. Look closely at your subject and try squinting your eyes; this blurs all the details and lets you focus on the lights and darks in your subject. Notice where the light is coming from and where the darkest shadows are. You'll find that even seemingly "pure" white actually contains many different colors. In this example, William Schneider explores the a variety of grays and pastel colors in a snow scene entitled *Waiting for Spring*.

Mixing Whites

When mixing values of white, as for snow, use a little of the colors of the elements around it, such as the sunset sky, green foliage, or brown grass. Don't be afraid to make the white look a little pink, blue, lavender, or yellow. Whites can actually have a whole range of pastel values— color doesn't have to be bright and bold to establish form.

White, cobalt blue, violet, cad. red medium, and black

White plus specks of violet, cobalt blue, and cad. orange

White plus specks of cad. yellow light and cad. orange

Color Palette

alizarin crimson, black, cadmium yellow light, raw sienna, terra rosa, titanium white, transparent oxide red, ultramarine blue, viridian green

BASIC TREE MIX #1

Ultramarine blue, black, cadmium yellow light, terra rosa, and white

BASIC TREE MIX #2

Ultramarine blue, black, cadmium yellow light, terra rosa, and white

BASIC TREE MIX #3

Cadmium yellow light, black, ultramarine blue, and terra rosa

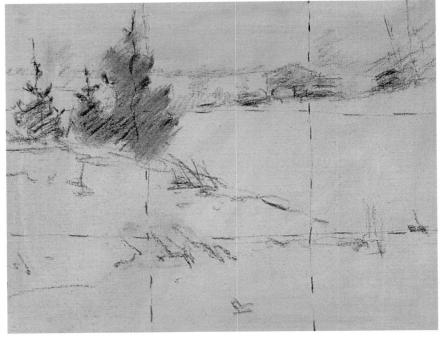

1 I start by toning a stretched canvas with a wash of terra rosa and viridian green thinned with turpentine; this warm underpainting will serve as a good base color for building the white snow. After wiping off most of the wash and letting the canvas dry to the touch (about 10 minutes), I use vine charcoal to divide the canvas into thirds horizontally and vertically and to sketch in the general placement of the main elements: the distant tree line, the pine trees, the middle ground buildings, and the foreground tufts of grass.

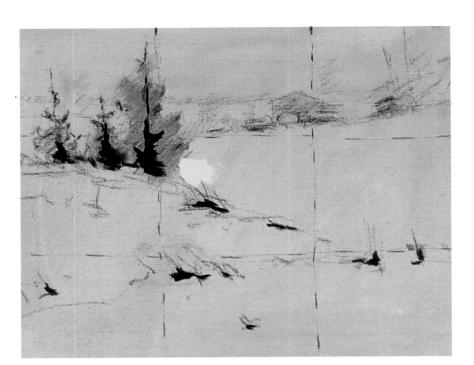

2 Next I establish my extremes: the lightest and darkest values. They set up a frame of reference for all the other values in the painting. I use a mixture of alizarin crimson, ultramarine blue, and transparent oxide red with a large filbert bristle brush to block in the darks. All of the middle ground snow is the same value (a mixture of white, ultramarine blue, black, terra rosa, and raw sienna), so I just swipe it on with one stroke of the palette knife.

3 I block in the sky with a mix of white, ultramarine blue, black, alizarin crimson, and raw sienna. The sky at the horizon is lighter and creamier, so I add more white and raw sienna to my original mixture. I paint the distant trees using a darker value of the sky mixture, softening the edges by blending them slightly into the sky. I try to keep the shapes of the trees irregular so that they don't look too symmetrical, like cookie-cutter cutouts.

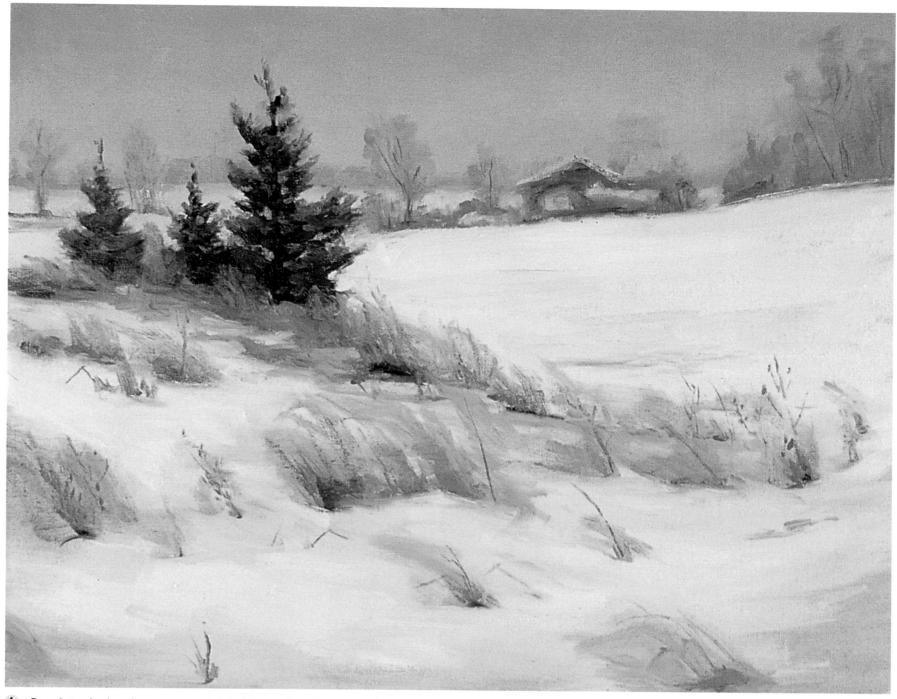

6 Once I step back and assess my work, I decide to paint a few more tufts of grass in the foreground and add some red to the barn to complete the design. One final observation—this painting has no pure or intense color. It is really a symphony of beautiful grays. In general, the world is a much grayer place than we think at first glance.

4 Working forward, I lay in the white values of the distant and middle ground snow, making sure the contrast between them is noticeable. Then I block in the buildings with a combination of the basic tree mixture #1 and some more terra rosa and raw sienna. For the shadows in front, I block in a slightly darker version of my snow color (see step two). Next I paint the pine trees with a medium bristle filbert, using the three basic tree mixes (see page 10) and leaving some of the dark value to indicate the tree trunks.

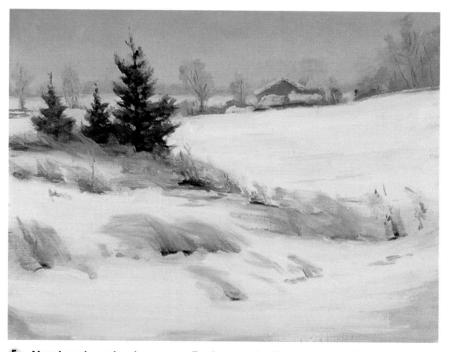

5 Now I work on the closest tree. For interest, I add a warm mix of ultramarine blue, terra rosa, raw sienna, and speck of white to indicate dead pine needles. I paint in the foreground snow with a warm mix of white, terra rosa, ultramarine blue, and raw sienna. Using a large bristle filbert, I lightly drag in the grasses in the middle ground. Finally I place a few sharp, defined strokes with a small round brush to indicate individual tufts of grass in the foreground.

11

Portraying Street Scenes

by William Schneider

URBAN LANDSCAPES can be as colorful and compelling as their more traditional counterparts. And if you live in the city, they may be your most accessible subjects. There are many stories you can tell about a city street; it all depends on the focal point of your scene. You may choose to focus your cityscape on some interesting architecture, the somber mood of a rainy day, or the intimacy of a sidewalk café.

Creating a Mood with Color

The mood of a cityscape is often determined by the colors the artist uses. For example, a busy morning scene at a beachside restaurant will utilize a much different palette than a calm, shadowed afternoon in a playground. Generally warm colors portray a sunny, upbeat mood, whereas cool colors seem more serene or mysterious. Here William Schneider uses cool pastel hues to capture the tranquility of a shadowy afternoon on Sheffield Avenue in Chicago, Illinois.

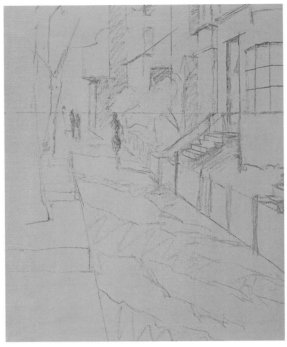

1 I tone a stretched linen canvas with a warm underpainting of terra rosa and cadmium yellow deep. Then I use vine charcoal to draw the horizon line about a third of the way down the canvas and sketch in the main shapes.

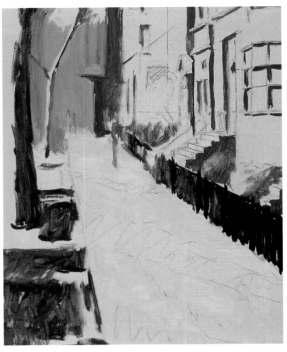

2 With a warm mixture of black, ultramarine blue, transparent oxide red, and alizarin crimson, I block in the deepest darks (the fence and the foreground shadows). Then I lay in the lightest area—the warm gray sidewalk. For the secondary darks in the fence and flower boxes, I add viridian green and a little raw sienna to the original dark mixture. I paint the remaining dark areas thinly with a medium bristle filbert, and I block in the background with a mixture of terra rosa, black, and white. The distant tree is a mixture of viridian green, black, terra rosa, and white. Working forward with a medium flat bristle brush, I define the light side of the farthest building on the right with a mix of terra rosa, raw sienna, white, and viridian green.

Color Palette

alizarin crimson, black, cadmium yellow deep, cadmium yellow light, raw sienna, terra rosa, titanium white, transparent oxide red, ultramarine blue, viridian green

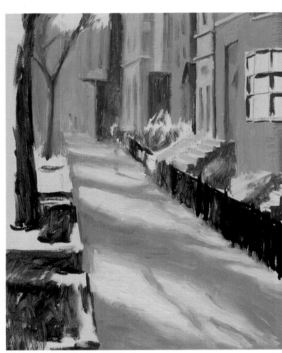

3 I mix terra rosa, raw sienna, cadmium yellow deep, viridian green, and white for the brick buildings and then paint the light areas on the tree by adding raw sienna and white to the dark mixture from step two. I paint the building next door with two values—the light side is a mix of viridian green, raw sienna, white, and terra rosa. (I use the same mixture for the rest of the light sidewalk.) For the dark side, I use the same mix but substitute transparent oxide red for terra rosa. I mix viridian green, raw sienna, white, and transparent oxide red for the windows and the dark side of the tree. I use a palette knife to loosely suggest shadows on the sidewalk with raw sienna, black, transparent oxide red, and white. I paint the porch roof with viridian green, ultramarine blue, raw sienna, and white.

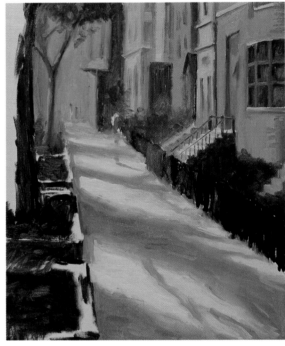

4 Working forward, I paint the porch and stairs with a mix of raw sienna, white, cadmium yellow deep, viridian green, and white, and I create the windows and doors. I apply a slightly darker value of the brick mixture in the shadows of the round building. I also use this darker value to indicate a few bricks. Then I paint in the porch rails, the window edges, and the fence with a dark green mix of viridian green, raw sienna, terra rosa, and white. Notice that I don't try to paint individual bars in the fence; I merely place a few vertical strokes to indicate the posts. I build up the values in the dark green of the shadowed foliage near the porch and in the flower boxes with a mix of black, cadmium yellow light, and ultramarine blue.

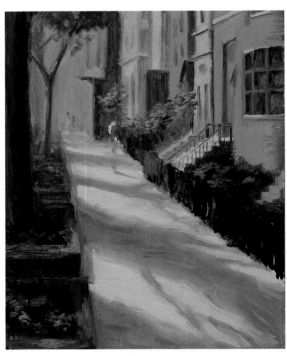

5 Here I pay close attention to the contrasts between the warm, sunlit patches and the cool shadows; this contrast will help set the mood of this scene. I paint the flower boxes and the large tree with two values: The darks consist of transparent oxide red, ultramarine blue, raw sienna, and a little white; the light areas are a mixture of transparent oxide red, viridian green, raw sienna, cadmium yellow deep, and white. Next I finish the foliage in the flower boxes and the yards. For the distant sunlit leaves, I use a mixture of black, cadmium yellow light, terra rosa, and white. Then I create a lighter mixture for the leaves in the foreground with viridian green, cadmium yellow light, and white.

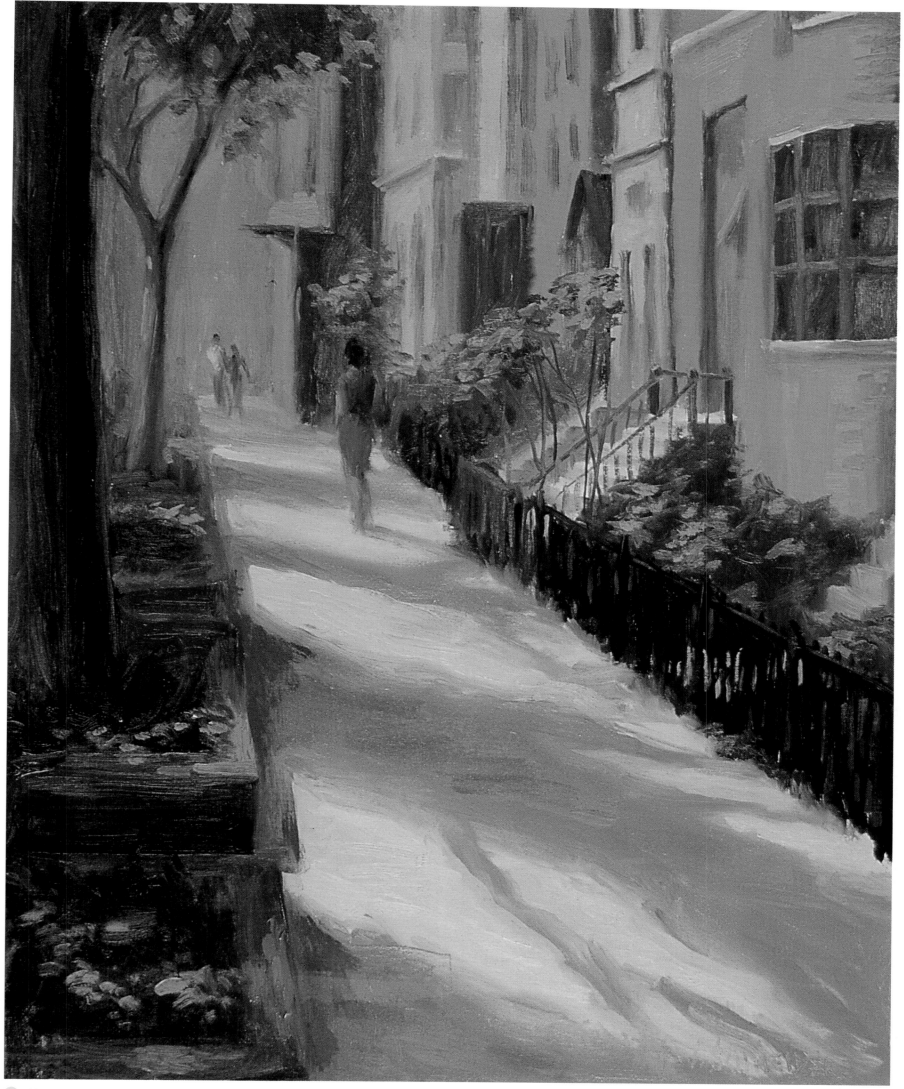

6 Now I suggest the figures with a small sable brush. I paint the red skirt with a mix of terra rosa, alizarin crimson, and white, adding a little black for the shadows. The blouse is the color I used for the porch (see step three) with a touch of black for the shadowed side. I mix terra rosa, raw sienna, viridian green, and white for the flesh tone. Finally I use some of the porch and leaf colors to indicate the spaces in the iron fence. In this case, it's better to paint the *negative spaces* (the areas around and between objects) with the background color rather than trying to paint the narrow lines of the fence itself.

Composing a Landscape

by Michael Obermeyer

A GOOD LANDSCAPE PAINTING has more than just an interesting subject—it also has a dynamic composition. *Composition* refers to the relationships among the objects in a scene. A good composition uses interesting colors, shapes, and lines to lead the viewer's eye on a visual path into and around the painting, toward the *center of interest* (also referred to as the *focal point*). Equally important, especially in a landscape, is the placement of the horizon line.

Placing the Horizon Line

The *horizon line* is the point where the sky appears to meet the earth, and it can be seen most clearly when looking out over a large field or the ocean. But a horizon line can also be whatever horizontal line is level with the viewer's eye. It may be hidden behind mountains or buildings, but its placement often determines the focus of the painting: A high horizon will emphasize whatever is in the foreground, while a low horizon will emphasize the sky or the background. To avoid a stagnant composition, try not to place the horizon directly in the center of your support. Notice that here Michael Obermeyer places the horizon line just below center, demonstrating how a simple, balanced composition can result in a beautiful landscape.

Color Palette

alizarin crimson, cadmium red light, cadmium yellow deep, cadmium yellow light, cerulean blue, titanium white, ultramarine blue, viridian green

▶ **POOR DESIGN**
In this sketch all the elements are crowded into the center and are on the same plane. The shape of the trees and its branches are too uniform, and the path leads the eye out of the picture.

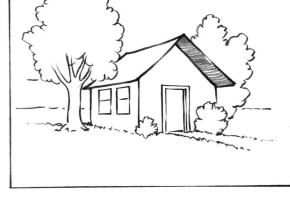

▶ **GOOD DESIGN** Here a few subtle changes have greatly improved the composition. The center of interest is off to the side, the elements are on different planes and are overlapped, and the eye is led into the scene and stays there.

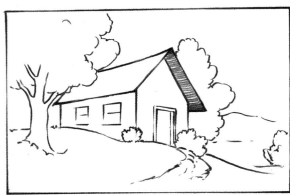

TREES

Alizarin crimson, cadmium yellow deep, cadmium yellow light, and ultramarine blue

SKY

Cadmium yellow light, viridian green, cerulean blue, and white

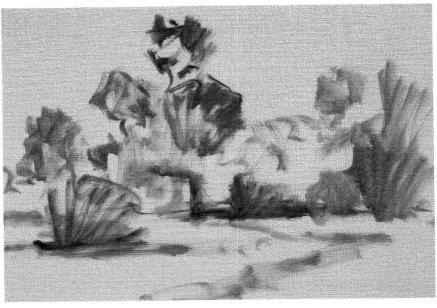

1 Using a light wash of ultramarine blue, I draw the scene on the support with a small brush, using my field sketch as a reference. I'm not concerned with details at this point—this is just a quick layout to outline the major elements. I also indicate the visual path (in this case, a literal path) that will lead the eye toward my focal point (the large trees on the left).

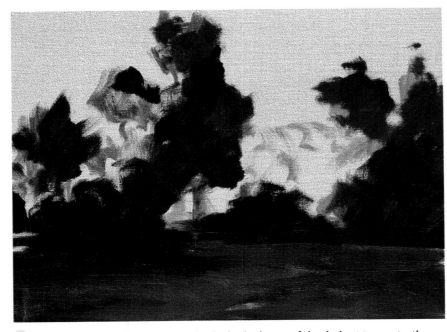

2 Using flat sable brushes, I block in the basic shapes of the darkest trees, starting with the warm, intense colors and values in the foreground. I use a mix of viridian green, cadmium red light, and ultramarine blue, keeping the darkest values in the trees so that the contrasting warm colors around the trees will appear to "pop" forward.

3 Now I begin blocking in the sunlit trees with a mixture of alizarin crimson, cadmium yellow deep, ultramarine blue, and cadmium yellow light. I use large flats and brights alternately, painting quickly with thick paint and bold brushstrokes. Then, using medium-sized flats, I paint in the pathway and the variety of dark and light areas on the grass in the foreground with mixes of ultramarine blue and cadmium yellow light.

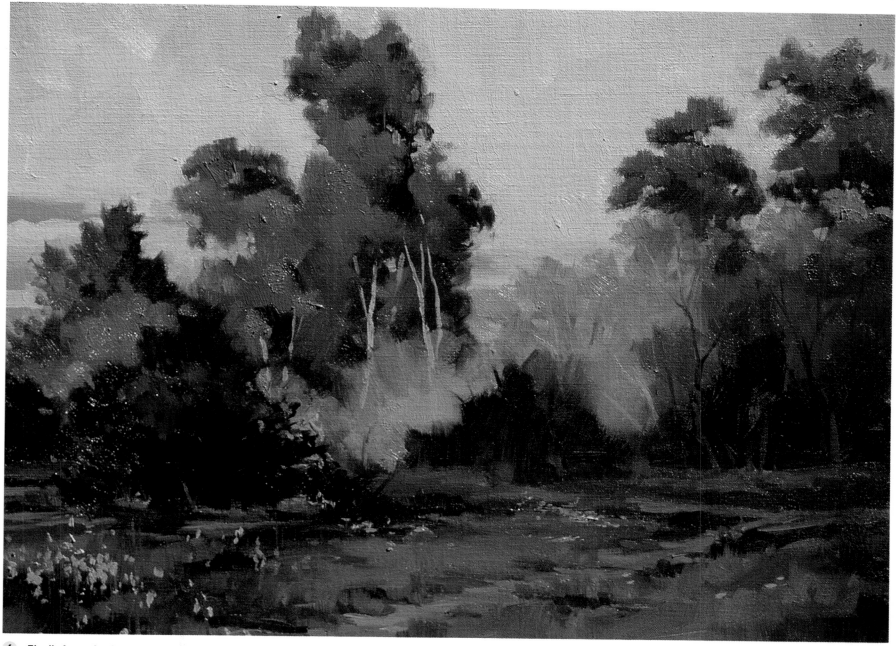

6 Finally I step back and take a look at my work. I check to see whether any of the values need adjustment and decide to add some colorful flowers in the foreground to anchor the viewer's eye at the left of my composition, where the focal point is located.

With a rigger brush and a mix of cadmium yellow light and white, I lightly dab in the blossoms, taking care to keep them in proportion. Now I'm happy. The most difficult part is knowing when the painting is finished and putting the brush down!

4 With a large flat, I paint in the sky with a mixture of cerulean blue, cadmium yellow light, viridian green, and a lot of titanium white. I combine ultramarine blue, alizarin crimson, and white to dab in the dark areas of the low clouds. For the sunlit areas of the clouds, I use a mix of cadmium yellow light, alizarin crimson, and white, painting right up to the edges of the trees.

5 Now I add details to the trees with a small flat brush, softening the edges as I work. I use the colors from step three and work all over the trees, never spending too much time in one area. Then I add the tree trunks and the finer details in the foreground grass with a rigger brush. This brushwork is tighter and the edges are sharper than those in the background which helps bring attention to my focal point.

15

Creating Drama with Light and Shadow

by Michael Obermeyer

OFTEN THE MOST CAPTIVATING ASPECT of a scene is the interplay between light and shadow—whether it makes a location seem tranquil or sinister, it certainly adds drama and interest to the composition. And sometimes the contrast between light and dark is so striking that the interaction between them becomes the focus (and not just a contributing element) of the painting.

Comparing Light Direction

The direction and intensity of light influences the shadows and colors in a scene. When light is hitting the subject head-on, the shadows are minimal and colors take on an added brilliance. Light coming from behind the subject tends to flatten forms into silhouettes and to illuminate their edges, giving a halo effect. Three-quarter and side lighting create strong shadows and bright highlights; contrasts are sharp and perspective is accentuated, making forms look very three-dimensional. In this scene, Michael Obermeyer's depiction of a bridge in Central Park, New York, captures the long, cool shadows created by the three-quarter lighting of the late afternoon.

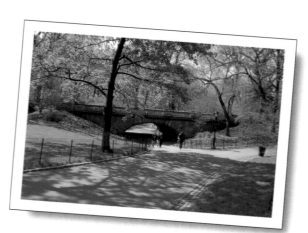

▶ **FOCUSING ON SHADOWS** This snapshot captures the natural, delicate balance between light and shadow in the afternoon. For my painting, I simplify these shadows slightly but try to retain the delicate laciness that makes them so interesting.

Color Palette

alizarin crimson, cadmium yellow deep, cadmium yellow light, cerulean blue, titanium white, ultramarine blue, viridian green

SHADOWED STREET

Ultramarine blue, alizarin crimson, and white

SUNLIT STREET

Alizarin crimson, cadmium yellow deep, and cadmium yellow light

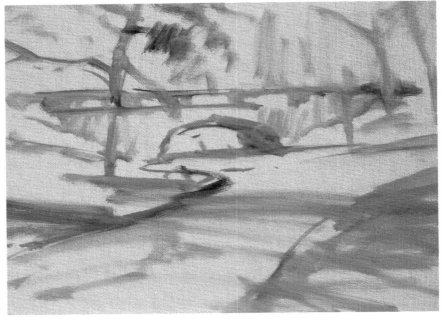

1 I quickly sketch in my composition with a thin wash of ultramarine blue, taking no more than five minutes to place the basic shapes. As I sketch, I keep in mind how the strong shadows will affect the other elements in my composition; I want the shadows to be my focal point.

Using a Viewfinder

A viewfinder can be an invaluable artist's tool. Consisting of two L-shaped frames, a viewfinder helps you to zero in on one section of a scene and to block out any unnecessary elements. It can also help you establish which format will make the most effective composition. You can buy one, make your own out of cardboard, or even use your own thumbs and forefingers. Hold the viewfinder up and look through the opening at the scene in front of you. Bring it closer to you or hold it further away; turn it sideways and move it around. Then choose the view you like best!

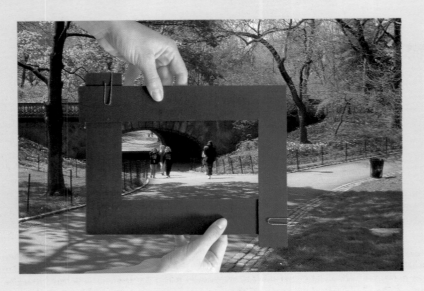

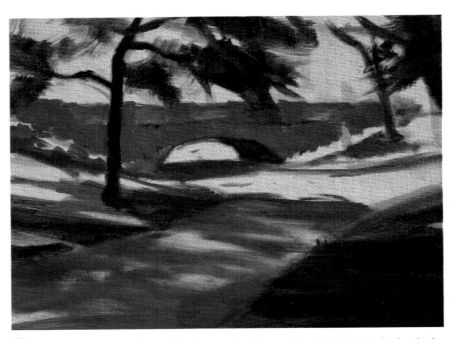

2 With a thin mix of ultramarine blue and cadmium yellow light, I block in the shadows on the grass with quick, bold brushstrokes. I place the tree trunks and the bridge with a mix of alizarin crimson and ultramarine blue. Then I use a large flat to work in the cool shadows on the road and trees, keeping the edges soft and the shapes simple.

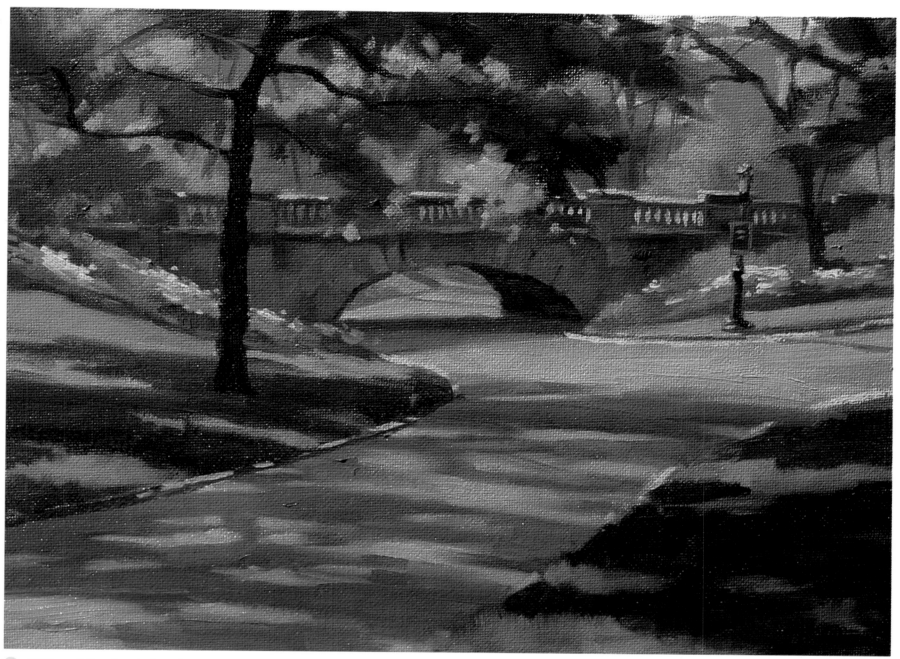

5 With small flats, I work throughout the entire painting, adjusting values as necessary and adding branches and a bit more detail to the trees in the foreground. With the same small brushes, I continue developing details on the bridge, the curbs, and the flowers. I include a little more detail on and under the arch of the bridge, keeping the edges sharp to draw some attention there. I place the signpost and refine the tree trunks, but I try not to overwork any one area of the painting and avoid putting in too much detail. I step back to assess my work again and decide that the contrast between the sunlit patches and the cool shadows is well balanced; my painting is done!

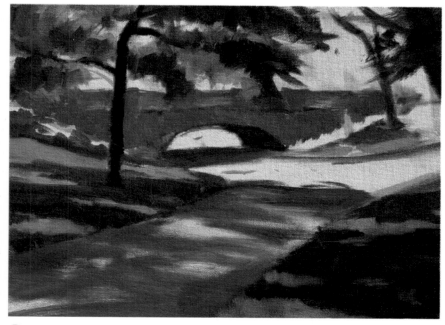

3 Now I add the warmest tones: the sunlit grass in the foreground and the light areas of the tree in front. I keep the paint thick, using strong, bold brushstrokes and not worrying about detail at this point. For the grass, I use a mix of cadmium yellow light with a touch of viridian green and a speck of cadmium yellow deep.

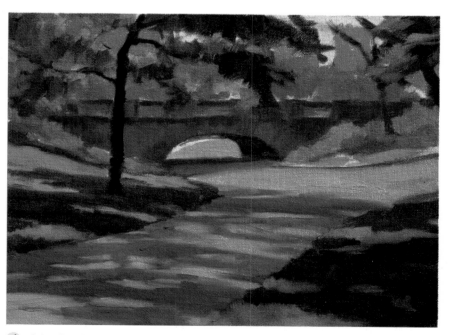

4 I develop the sunlit areas of the street with a mix of cadmium yellow light, alizarin crimson, white, and a touch of cadmium yellow deep. I add the sky (cerulean blue, white, and cadmium yellow light) and the distant trees (alizarin crimson, ultramarine blue, and white). Then I block in the distant buildings with a mix of ultramarine blue and white.

17

Focusing on Architecture

by Michael Obermeyer

MANY ARTISTS ENJOY PORTRAYING LANDSCAPES that also contain an element of architecture—the contrast between the natural and the structural elements of a scene can create a dynamic composition. However, sometimes a building is so unusual or interesting that it can become the focus of a landscape. The height and length of a structure can determine what format you choose for your painting.

Choosing a Format

Format is the shape, size, and orientation (horizontal or vertical) of a painting. Horizontal formats can showcase a sweeping, dramatic view of a scene (such as a seascape or a desert scene), while vertical formats tend to emphasize a more intimate, personal focus (such as a tall tree or a building). Before you begin painting, try sketching your subject in several different formats to decide which you prefer, as Michael Obermeyer has done below. Then he chose a horizontal format to showcase a charming Spanish-style house in a colorful natural setting.

Color Palette

alizarin crimson, cadmium red light, cadmium yellow deep, cadmium yellow light, cerulean blue, titanium white, ultramarine blue, viridian green

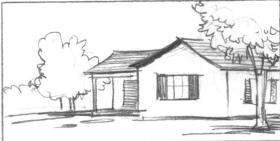

FINDING A FOCUS
By making some quick thumbnail sketches of a subject, you can determine the emphasis of the scene. Here you can see how three different formats of the same scene each have a slightly different viewpoint.

STUCCO

Alizarin crimson, white, cadmium yellow light, and cadmium yellow deep

HOUSE SHADOWS

Ultramarine blue, alizarin crimson, and white

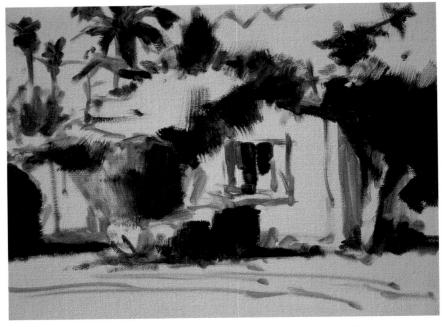

1 I use a light wash of ultramarine blue to loosely draw my composition on the canvas. I keep the paint thin so I can easily rework or adjust the sketch if necessary. Then I use a large flat sable brush and bold, quick brushstrokes to block in the darkest areas with a thin mix of ultramarine blue, alizarin crimson, and a touch of viridian green.

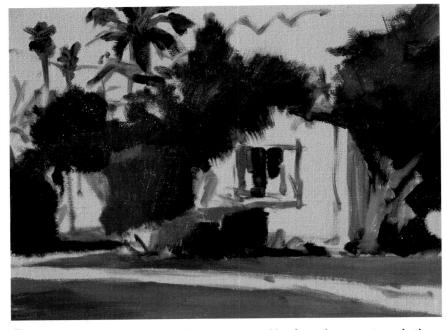

2 Next I block in the rest of the basic shapes, working from the warm tones in the front to the cool tones in the back. I paint the tree trunk with a mix of cadmium yellow light, cadmium red light, and white. I use a large filbert and block in the trees and grass with mixes of ultramarine blue and cadmium yellow deep. Then I mix in some viridian green and cadmium yellow light for the cooler areas, keeping the shapes simple.

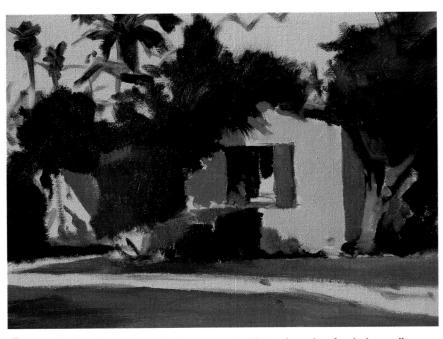

3 Now I paint the stucco with a thick mix of white and specks of cadmium yellow light, cadmium yellow deep, and alizarin crimson. Using a small flat brush, I dab in the shutters with a mixture of cerulean blue and a little ultramarine blue. I create the shadows on the side of the house with a mix of ultramarine blue, alizarin crimson, and white.

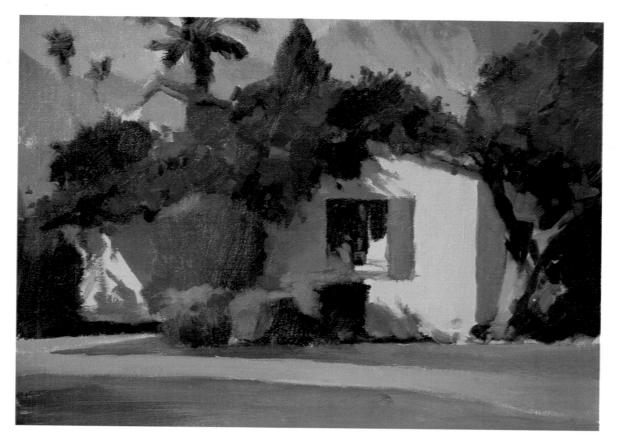

4 Now I begin to work all over the painting with a small flat brush, building up thick highlights and adding a variety of brushstrokes for interest. I refine the shadows on the house with a small filbert, keeping the edges soft. Then I paint the mountains in the background with a mix of white, alizarin crimson, cadmium yellow deep, and a touch of ultramarine blue, adding more ultramarine blue and a touch of alizarin crimson for the shadows. I paint the roof with small flat brushes and a mix of cadmium yellow light, cadmium red light, cadmium yellow deep, and a touch of ultramarine blue. I also paint in pure alizarin crimson for the base color of the flowers.

FLOWERS

Ultramarine blue, cadmium red light, alizarin crimson, and white

Artist's Tip
Keep a photo reference file of interesting scenes and locations that you may want to paint someday; it can be a wonderful source of inspiration!

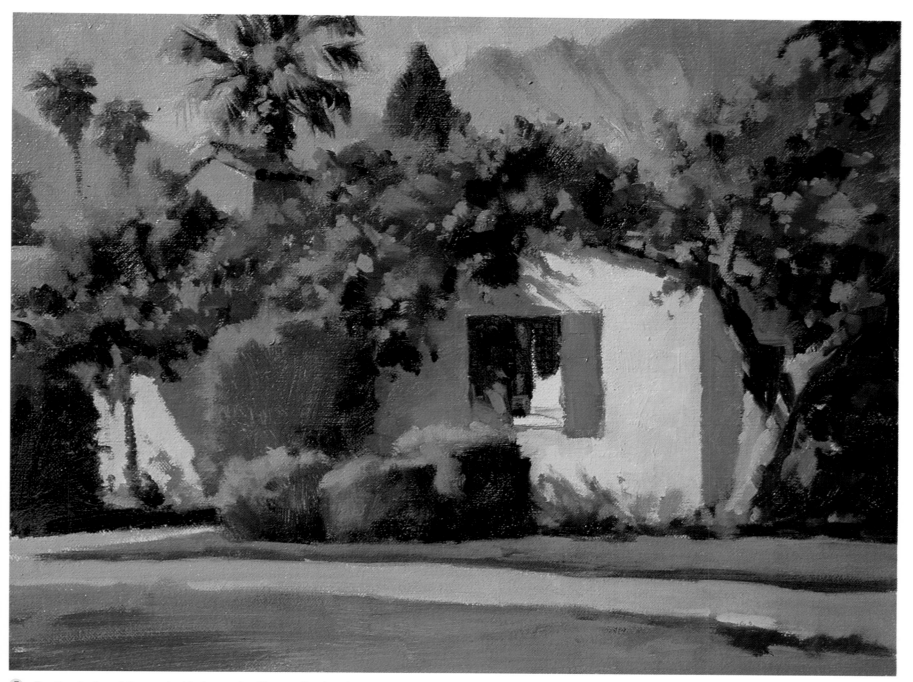

5 For the shadowed flowers, I add ultramarine blue to alizarin crimson. I paint highlights and details in the flowers using alizarin crimson and cadmium red light with a touch of white, dabbing the paint on with small flats and brights. I move around the painting, adding details to the mountain, tree trunk, plants, mountain, and shadows.

Next I apply highlights to the shrubs with a mix of the original color plus more cadmium yellow light. I paint more details on the palm trees, keeping their edges softer than those of the foliage in the foreground. Finally I add details on the windowpanes with a small brush and a mix of cerulean blue and a small amount of ultramarine blue.

Capturing a Time of Day

By Kevin Short

THERE IS SOMETHING ALMOST MAGICAL about capturing a particular time of day on canvas; the first few moments of light at sunrise or the waning warmth of twilight can turn an ordinary setting into a gorgeous and compelling landscape. Colors, light, and shadows are all different at various times of the day; for example, there are cool hues and longer shadows in the morning and early evening, and there are warmer hues and shorter shadows at mid-day. And all these factors will contribute to the emotional response your painting will arouse. Portraying the feel of a particular time of day may require you to shift your regular color palette slightly or even to reconsider your viewpoint or composition for maximum effect, but it's well worth the extra effort!

Painting Sunsets

Nature offers nothing more impressive than a vibrant sunset. Whether you live in the city or in the country, you can always appreciate the beauty of the setting sun. And striking sunset scenes often call for bold brushstrokes and strong hues; here is a chance to throw off any timidity you may feel and experiment with color. But try to stay away from white paint. The sunset sky isn't full of white light—the light is bathed in reds and oranges. These are colors you don't get to use very much in landscapes, so lay these bright hues in with confidence, and watch the fiery skies emerge on your canvas! Here artist Kevin Short uses an array of mixes and pure color to capture the last few fleeting moments of light on a southern California beach.

Color Palette

cadmium orange, cadmium red light, cadmium yellow medium, Carbazole violet, medium blue, phthalo green, quinacridone red, quinacridone violet, titanium white

SKETCHING THE VISUAL PATH I begin by sketching out some small layout ideas to help me figure out the "flow" of the design. In this case I'm using the perspective (see pages 24–25), the surfer's gaze, and the surfboard as strong directional elements. The arrows on the thumbnail sketches show how the viewer's eye will be led first to the surfer and then out to the rest of the painting.

1 Using a large filbert brush, I start with a thin mix of the darkest shadow color (Carbazole violet, quinacridone violet, medium blue, and white) and draw over my pencil sketch. I paint the darkest sections first: the shadows of the tracks, the edge of the bluffs, and the surfer (see color sample below). Then I use pure cadmium red light, quinacridone red, and cadmium orange to block in the sand and sky and medium blue for the ocean. Because this is a sunset scene, the overall tone of the painting is warm, so even the "cool" shadow colors will seem warm next to the warm tones.

TRACK SHADOWS

Medium blue, Carbazole violet, quinacridone violet, and white

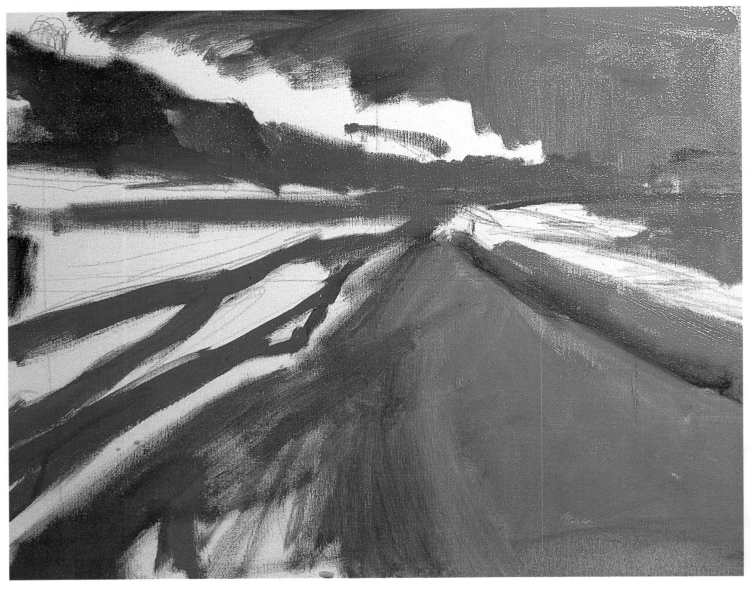

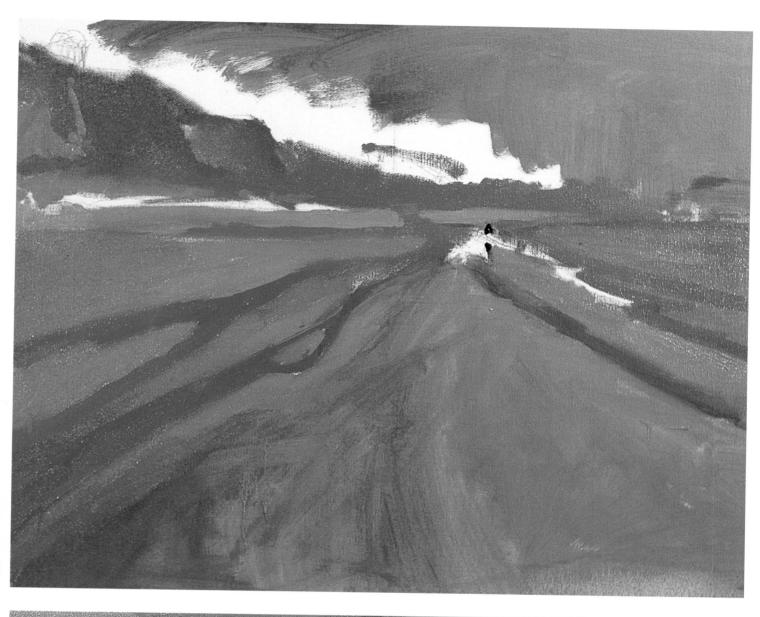

2 My goal at this point is to get rid of the white of the canvas by blocking in all the major areas of color. With a medium bristle brush, I scrub in cadmium red light, quinacridone red, and cadmium orange for the sand near the shoreline. I blend in some more cadmium red light and cadmium orange as I paint toward the tire tracks, and I add Carbazole violet to this same mixture to block in the rocky bluffs. Then I mix the sand color with medium blue, phthalo green, and white for the water.

OCEAN

Carbazole violet, medium blue, and white

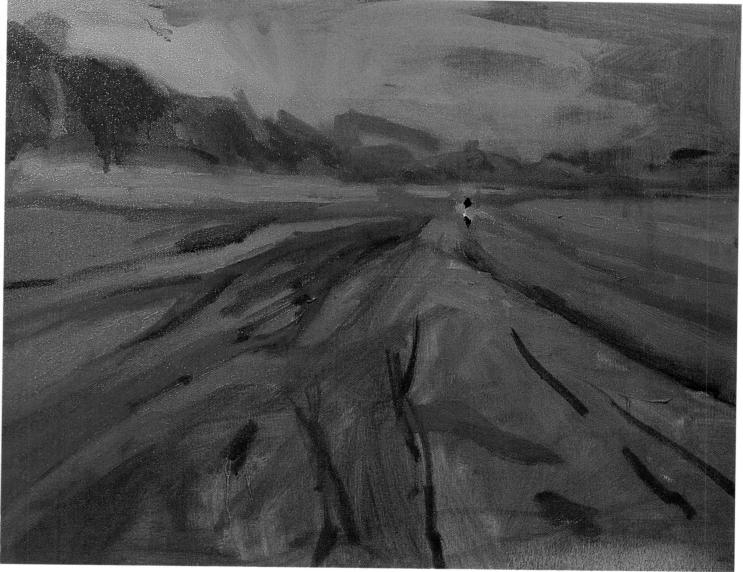

3 With a medium round brush, I block in the rest of the sky, blending from top to bottom as I work. I use pure colors here—I can always correct them later if they look too bright. Next I apply cadmium yellow medium with a touch of phthalo green at the top. (This is also the same color I use for the surfboard.) Then I use cadmium orange in the lower half of the sky, and I add a little quinacridone red at the horizon line. The distant ocean is a lavender mix (see color sample above) that I blend up into the sky, adding a little quinacridone red to make it hazy and help create the illusion of depth. The foam on the waves isn't actually white; the dark part is a greenish blue (phthalo green, white, cadmium yellow medium, and medium blue), and the highlights are pink (quinacridone red, white, and a little cadmium yellow medium). I place all these colors with a small round brush.

4 Next I start working on the distant bluffs. With a small filbert and a combination of phthalo green, cadmium yellow medium, and some of the orange sky mixture, I paint the sides of the middle bluffs. As the bluffs recede into the distance, I add a little more sky color to the blend. For the closest part of the bluffs, I use a rich mixture of cadmium orange, quinacridone red, cadmium yellow medium, and a little white and lay it on thickly with a small filbert. I also mix the sand shadow color into the bluff shadow color to create a third value that I use to further develop the forms of the bluffs.

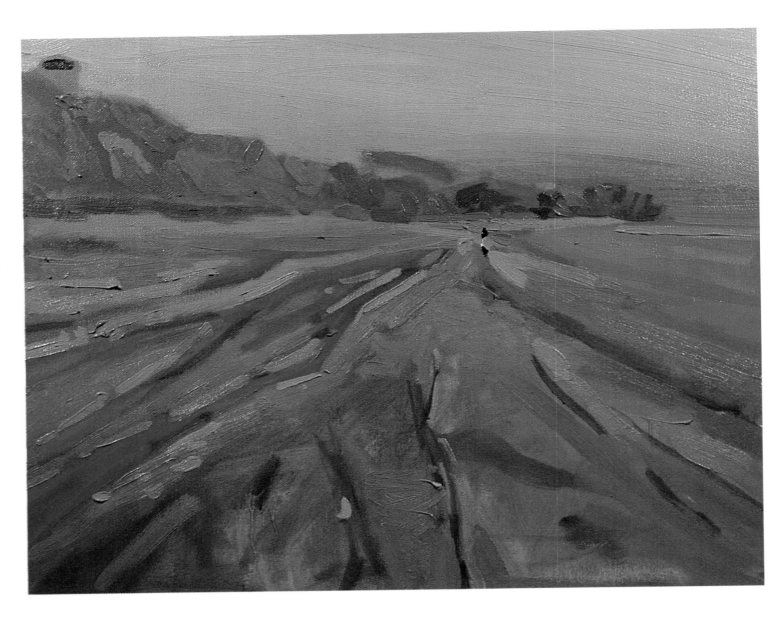

5 I add the lifeguard tower and distant houses with a mix of cadmium orange, cadmium yellow medium, phthalo green, and a little white. The houses farthest away are a cool, rosy purple (a mix of Carbazole violet and white with a little of the orange sand color). I use a lighter warm orange mix (cadmium orange, cadmium red light, and cadmium yellow medium with white) for the highlights. Using a small filbert and a bright yellow mix of cadmium yellow medium, a touch of phthalo green, and white, I create green highlights on the surfboard to draw the eye directly to the surfer. This complementary highlight will capture the viewer's eye, much the same way the only two red umbrellas amid hundreds of black umbrellas attract attention. I refine the surfer with a small round brush and a very dark mix of Carbazole violet and phthalo green.

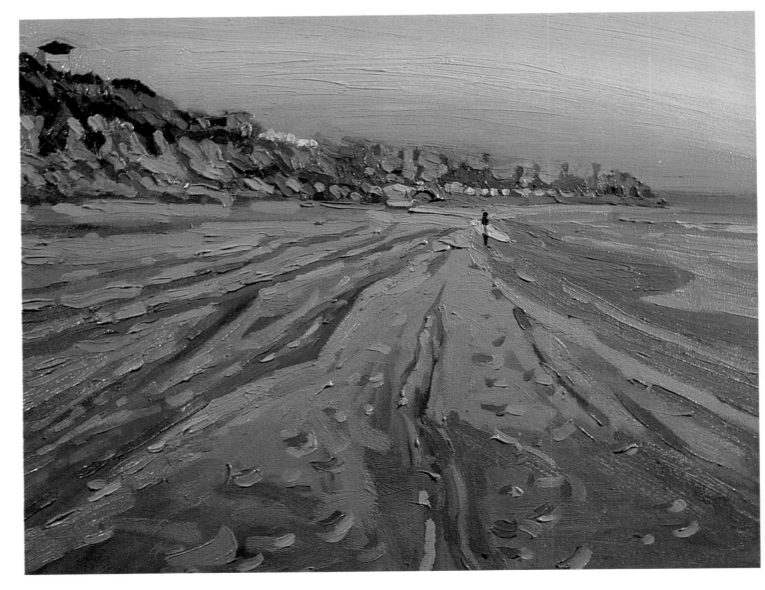

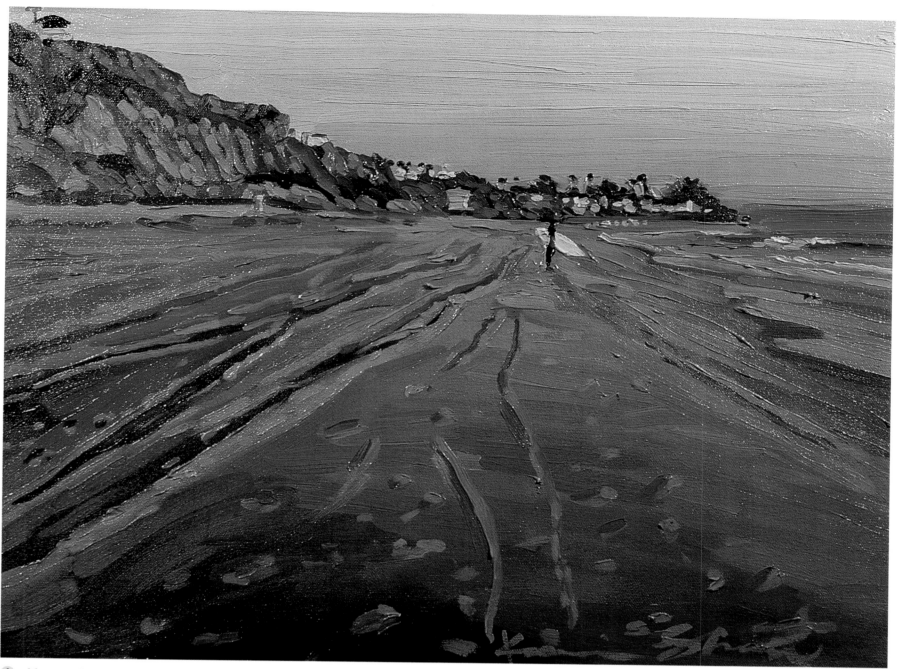

6 After standing back and assessing my work, I decide to make some slight alterations. I lighten up the sky by mixing a light creamy color (white, cadmium orange, cadmium yellow medium, and quinacridone violet) directly into the wet sky color and blending it in evenly with a medium round brush. I think the sand needs to be cooler, so I work some blue into the wet paint with a small filbert. The tire tracks need a slightly darker shadow—I mix a dark purple and dab it on top of the tracks, leaving some of the original color showing through. I also change the shape of the tracks slightly, straightening out a few bumps. Since the foreground highlights in this painting are the center of interest, I've created them with careful and deliberate strokes and left the other elements in the painting loose and less detailed.

HIGHLIGHTING For the highlights on the tire tracks, I use a mix of cadmium red light, Carbazole violet, and cadmium yellow medium. I heavily load a round brush and paint short, simple strokes along both sides of the tracks. These highlights are bright and rich because they are an important element in the painting.

PAINTING FIGURES I use just a few simple brushstrokes to create the figure in the distance. Notice that even with absolutely no rendered detail, your eye fills in what the brushstrokes only suggest: a surfer walking with a surfboard. Scale is important, so pay attention to the size of the figure in relation to its surroundings.

Introducing Perspective

by Kevin Short

A FEW SIMPLE TRICKS will help you impart a sense of space and distance in your landscapes; one of these tricks is using perspective. *Perspective* is the representation of objects in three-dimensional space to give the illusion of distance. You probably already know more about perspective than you think. If you've ever looked at rows of telephone poles that seem to converge at a spot in the distance, you have observed linear perspective.

Using Linear Perspective

Linear perspective is simply the idea that objects become smaller as they recede into the distance. These receding lines appear to converge at a point on the horizon called the "vanishing point." If the lines are on one plane, as with railroad tracks, the receding lines converge at one vanishing point; this is called "one-point perspective." If two planes are involved, such as a house viewed from one corner, each plane has its own vanishing point; this called "two-point perspective." (For more detailed information on perspective, refer to *Perspective* by William F. Powell in Walter Foster's Artist's Library series.) Artist Kevin Short demonstrates a perfect example of one-point perspective in this colorful rendering of Trestles Beach in San Clemente, California.

▶ **ONE-POINT PERSPECTIVE** To sketch a subject using one-point perspective, make all the parallel lines in the scene recede to the vanishing point (VP). First draw the horizon line and place a point on it to represent the vanishing point. Now draw light lines from your subject to the vanishing point, as shown in this diagram.

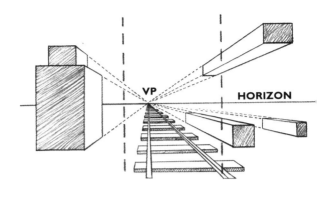

Color Palette

cadmium orange, cadmium yellow medium, Carbazole violet, phthalo green, quinacridone red, titanium white, ultramarine blue

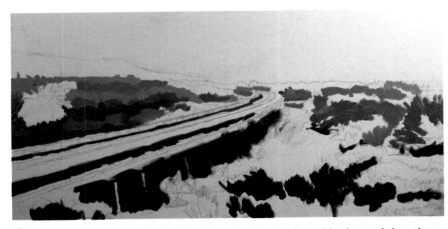

1 With a pencil, I draw the horizon line, then the tracks and bushes and the other basic elements, taking care to get the perspective correct. I paint the shadows of the trestle with a mix of Carbazole violet, ultramarine blue, and quinacridone red. As I paint toward the distant part of the trestle, I blend in a mixture of Carbazole violet, ultramarine blue, and white. With a small round brush, I block in the bushes with thick strokes that mimic their growth. As the foliage recedes into the distance, I use less and less blue until I am using a mix of only phthalo green, cadmium yellow medium, Carbazole violet, and white. This color change creates a color pathway that leads the viewer's eye through the painting, creating extra movement and interest.

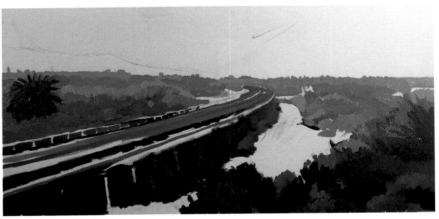

2 I add a little of the trestle shadow color to the darker mix I used for the bushes and place a few strong shadows in the foreground and near the trestle. I paint in the ocean on the right with a small flat brush and a mixture of ultramarine blue, phthalo green, and white. It looks bright now, but later I'll add some sky color to tone it down. I stroke in a mix of ultramarine blue, Carbazole violet, quinacridone red, and white onto the track with the same small flat brush. I also add more white and ultramarine blue to cool the mixture as the tracks disappear into the distance. Sometimes I mix colors together directly on my canvas; I find that the new colors that often appear in the blend help the overall color harmony of the painting.

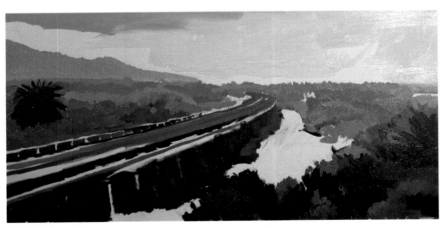

3 I block in the mountain and then create a pale yellow mixture for the sky with white, cadmium yellow medium, and ultramarine blue. I mix a lot of this sky color; I'll save some to blend it into the other color elements later to give the illusion of a very hazy atmosphere. And if an element of the painting "pops" forward too much, I simply add a little sky color to it. I start by first painting the mountain in the distance and then thickly laying on the sky colors with a medium round brush.

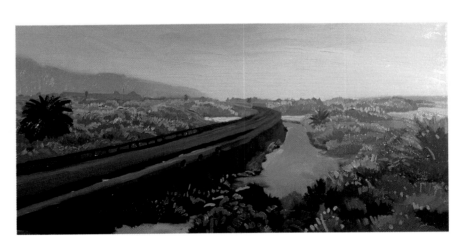

4 I blend some of the sky color into the mountain until it starts to disappear, alternating between the two colors. Then I scrub in the sand and add yellow to the edges of the path for variation. I add thick highlights to the bushes with various mixtures of ultramarine blue, cadmium yellow medium, white, and phthalo green. I save the brightest highlights for the foreground; I dab in flowers and highlights with a mix of cadmium yellow medium and a little cadmium orange, white, and phthalo green.

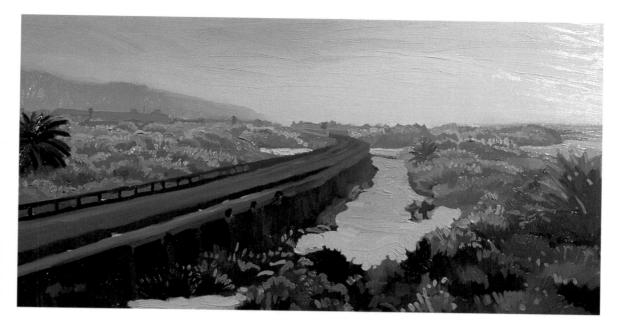

5 Next I add the final sand color and then darken the palm tree on the left to bring it forward with my small round brush and a mix of Carbazole violet, ultramarine blue, and phthalo green. I place the two figures with a small round brush and a dark mix of Carbazole violet, quinacridone red, and ultramarine blue. As the sandy path fades into the distance, I add some of the sky mix to my sand color near the horizon.

SAND	**SAND SHADOWS**
Carbazole violet, quinacridone red, cadmium orange, cadmium yellow medium, and white	Carbazole violet, ultramarine blue, quinacridone red, cadmium orange, cadmium yellow medium, and white

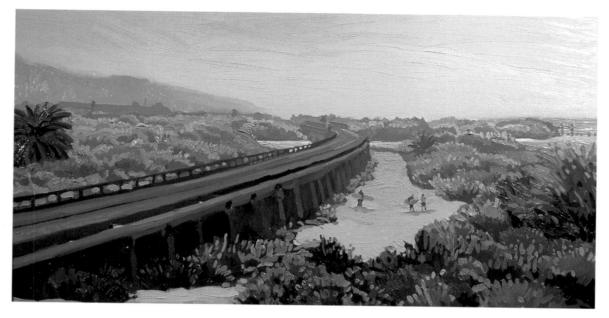

6 I add some bright red flowers to the bushes in the foreground with a mix of quinacridone red and white. I also paint in the structure on the right with a few quick strokes. Then I refine the figures by painting their clothes and surfboards and decide I'd like to add one more directional element. I quickly add a surfer going the other direction, and that does the trick.

Artist's Tip

Adding a figure or two to your landscape is a great way to grab the viewer's attention; the eye is naturally drawn to whatever is different in a scene.

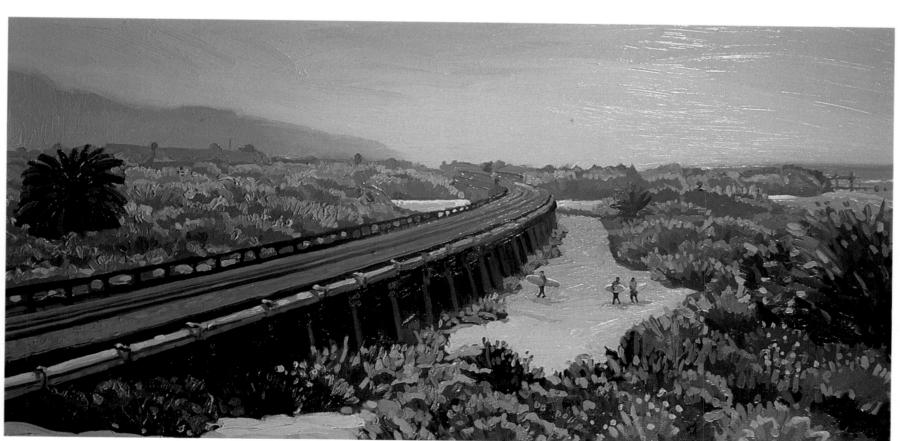

7 I finalize the tracks by painting highlights on the gravel. Starting with the track colors I used in step five, I add more quinacridone red and white. I highlight the tracks with more ultramarine blue and white and add a few last bright highlights to the foreground bushes.

Depicting Depth

by Anita Hampton

ONE OF THE MOST REWARDING ASPECTS of painting landscapes is watching a three-dimensional scene emerge on a flat, two-dimensional canvas. Aside from linear perspective, there are several other "visual cues" artists use to convey depth in landscapes, including overlapping and scale. Overlapping elements helps create an illusion of distance because objects set in front of other objects appear to be closer. And varying the size (scale) of similar elements (such as trees) works because the larger objects will appear closer than the smaller objects. Translating your favorite scene to canvas is not difficult when you use these simple visual cues to emphasize depth.

Conveying a Sense of Dimension

Another method of depicting dimension is to utilize *atmospheric perspective* (also referred to as *aerial perspective*). As objects, such as trees or mountains, recede into the distance, they appear lighter in value, more muted and cooler in color, and with fewer details than the objects in the foreground (see box at right). In this portrayal of *Hendry Beach,* artist Anita Hampton uses overlapping and distinctive color changes to create a sense of depth.

Color Palette

burnt sienna, cadmium red light, cadmium yellow deep, cadmium yellow pale, cerulean blue, cobalt blue, phthalo yellow-green, quinacridone rose, titanium white, ultramarine blue, viridian green, yellow ochre

Applying Atmospheric Perspective

Impurities in the air (such as dust, pollution, and water vapor) block out some of the light, making objects in the distance appear less distinctive and with softer edges. The impurities also filter out the longer, red wavelengths of light, allowing your eye to see only the shorter, blue wavelengths. The result is that objects look cooler and more blue as they recede into the distance. In the photo below, notice how much sharper, clearer, and redder the cliffs in the foreground are compared with the cliffs in the background.

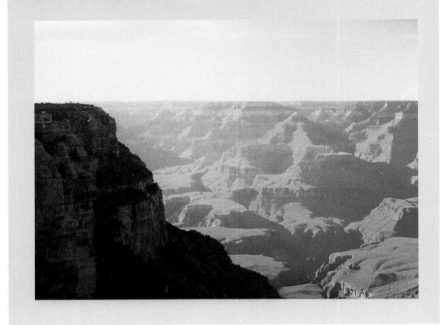

1 I sketch the composition directly on the canvas with a small flat bristle brush and a mix of cerulean blue and yellow ochre thinned with a little turpentine. If I need to make adjustments in my drawing, I can easily wipe off the color with a paper towel and solvent. I place the basic shapes carefully, making sure I have a variety of sizes and lines and a good placement for my center of interest—the trees on the left.

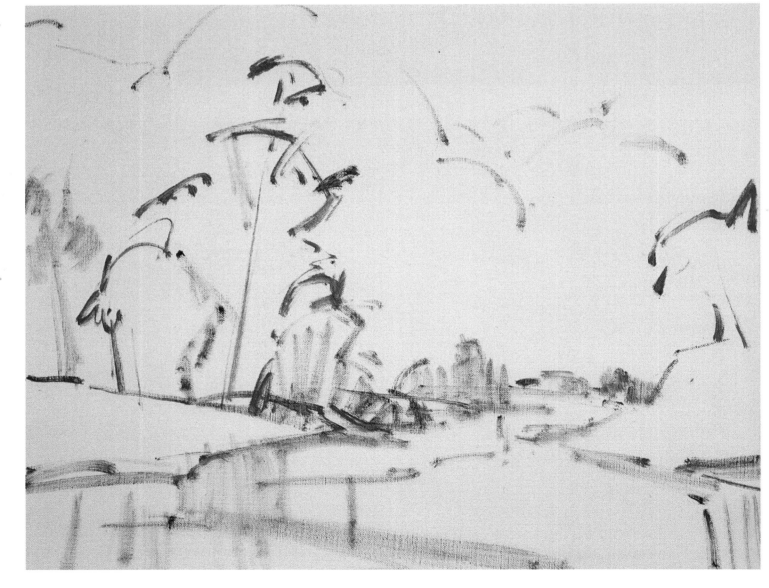

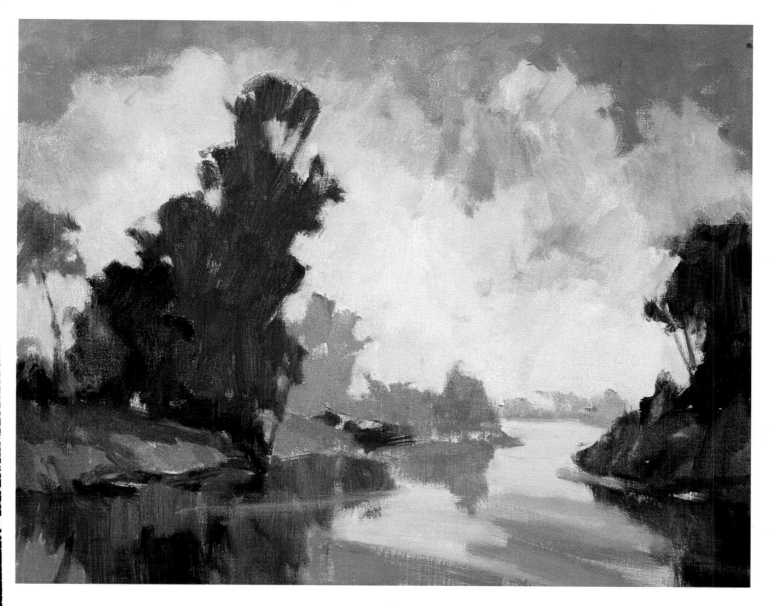

2 I begin by blocking in the dark trees with a large bristle brush and a mixture of viridian green, ultramarine blue, burnt sienna, and yellow ochre thinned with a little turpentine. As I lay in these shapes, I occasionally change the dominant hue by adding more of one of the colors to the mixture. I block in the rest of the foliage and the reflections, working toward my lightest areas (the clouds and sky). I mix white, yellow ochre, and a small amount of cadmium red light and cerulean blue for the white clouds. For the sky, I mix white, ultramarine blue, cerulean blue, and a touch of quinacridone rose. As the blue sky nears the horizon, I apply a mix of white, cerulean blue, and a touch of cadmium yellow pale. I take extra care to thoroughly clean, dry, and load my brush each time I change colors.

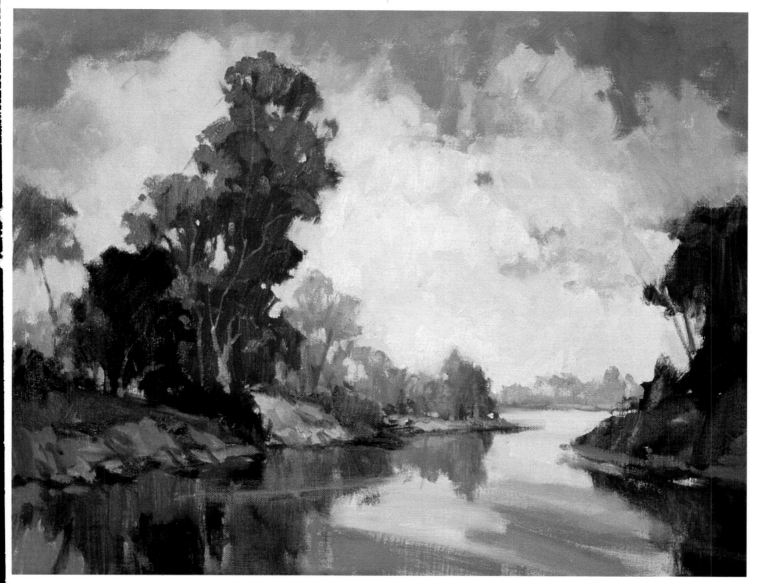

3 Now I develop the main shapes, starting with my center of interest. Using a small bristle brush, I apply color to the foliage shapes on the left with a mix of white, yellow ochre, cadmium red light, and a touch of phthalo yellow-green and cadmium yellow deep. I add the darker values in the shadows with a mix of white, viridian green, ultramarine blue, yellow ochre, and a touch of cadmium red light. I am careful not to overdevelop any of these outlying areas—this could detract from the center of interest. I paint all the tree trunks with a small rigger brush dipped in a mix of white, cadmium red light, viridian green, and yellow ochre.

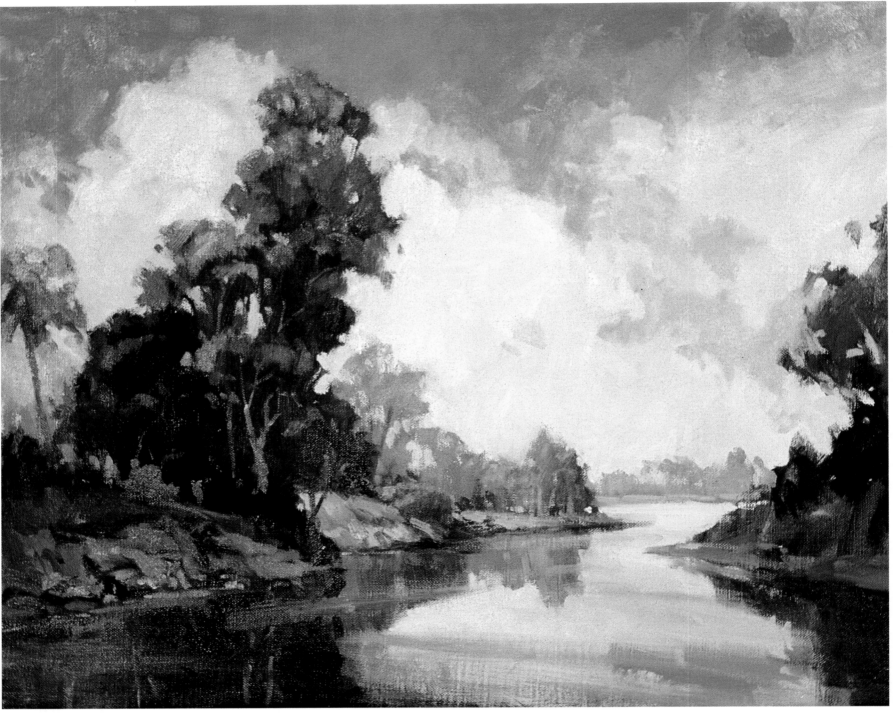

4 I develop the center of interest using a small bristle brush and my light and dark mixtures from step three. If I need a lighter value, I add a little more white to my mixes. I also work on developing the outlying areas with a large bristle brush. Using a large brush helps me maintain the large, soft shapes I've already created. During these final stages, I use more color and less gray in my mixtures as I slowly build up toward clean color. I also make sure to save the cleanest, purest colors for the foreground. Then I step back and view the final painting from a distance. If there are any areas that need correction or more attention, I handle them now.

▶ **ENHANCING DEPTH** This sketch combines several techniques for showing depth (sharpening or blurring details, overlapping objects, linear perspective, and emphasizing size differences), but the differences in scale are really accentuated in the road, fence, and trees. Notice that the receding lines of these elements narrow to the vanishing point on the horizon, bringing more attention to the depth of the scene.

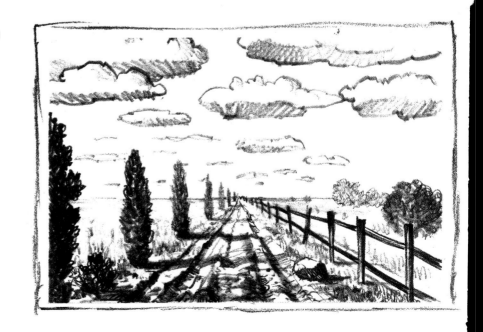